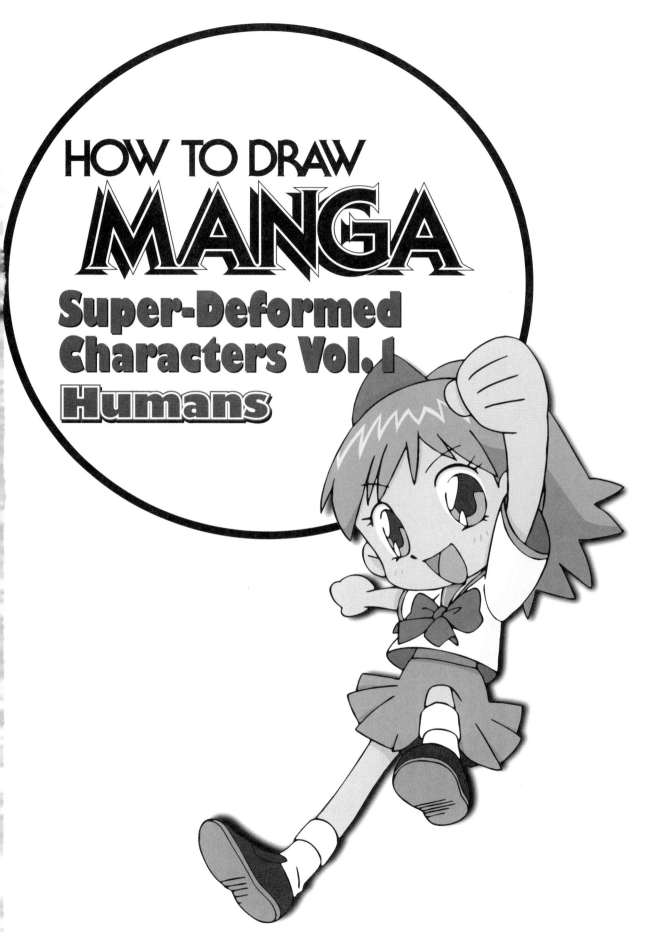

HOW TO DRAW MANGA

Super-Deformed Characters Vol. 1
Humans

HOW TO DRAW MANGA: Super-Deformed Characters Vol. 1
Humans
by Gen Sato

Copyright © 2003 Gen Sato
Copyright © 2003 Graphic-sha Publishing Co., Ltd.

This book was first designed and produced by Graphic-sha Publishing Co., Ltd.
in Japan in 2003. This English edition was published by Graphic-sha Publishing Co., Ltd.
in Japan in 2004.

Graphic-sha Publishing Co., Ltd.
1-14-17 Kudan-kita, Chiyoda-ku, Tokyo 102-0073 Japan

Cover Illustration: Gen Sato
Book Illustrations: Gen Sato and Asami Ogasawara
Assistance with Robotic Illustrations: Kanta Hino (Nippon Engineering College)
Original Book Design: Masako Okubo
Main title Logo Design: Hideyuki Amemura
Planning Editor: Kuniyoshi Masujima (Graphic-sha Publishing Co., Ltd.)
English Edition Layout: Shinichi Ishioka
English Translation Management: Língua fránca, Inc. (an3y-skmt@asahi-net.or.jp)
Foreign Language Edition Project Coordinator: Kumiko Sakamoto (Graphic-sha Publishing Co., Ltd.)

Distributed by
Japanime Co., Ltd.
2-8-102 Naka-cho, Kawaguchi-shi,
Saitama 332-0022, Japan
Phone /Fax: +81-(0)48-259-3444
E-mail: sales@japanime.com
http:// www.japanime.com

First printing: August 2004
Second printing: November 2004

ISBN: 4-7661-1435-3
Printed and bound in China by Everbest Printing Co., Ltd.

Table of Contents

Super-deformed characters are oodles of fun!

Hello there! What genre do you visualize when you hear the phrase "stylized characters"? Do you picture characters from gag *manga* (humorous *manga*)? Or do you picture corporate promotional characters? Perhaps you picture characters from parody *manga*, such as in games. The phrase conjures up any number of categories in our minds.

However, a little statistic that may come as a surprise is that 99% of all *manga* sold in Japan contains "stylized characters." Although not named as such, *manga* characters are exaggerated expressions of the human form. Consequently, if a non-Japanese were to declare that absolutely all of Japanese *manga* features stylized characters, there would be no denying it.

The real point is that we just do not see humans with eyes that big or with stars in them, like we do in *shoujo* (girl) *manga* (wry laugh).

While the characters discussed in this book are stylized, they do not cover all modes of *manga* found in Japan. Still, I would like to discuss ultra-stylized characters that do require heightened stylized techniques, also known as "super-deformed" or "chibi characters."

Perhaps you do not have a complete grasp of what I mean when I bandy about the phrase "super-deformed character." For simplicity's sake, in this book I use "super-deformed character" to refer to compacted human characters stylized to 1:2 to 1:4 head-to-body ratios.

Contrary to what your first glance might imply, super-deformed characters are exceptionally versatile and lend themselves to various situations. Consequently, their avenues of use are endless. We have all seen them in *manga* and anime. They also appear in commercials, as corporate mascots. We can use them in everyday situations, such as decorating a letter with a super-deformed character or portraying your family in a hyper-stylized way. Make an effort to learn how to draw super-deformed characters, and discover new fun ways of using them.

Chapter 1

○ ● ○ ● ○ ●

What are "Super-deformed Characters"?

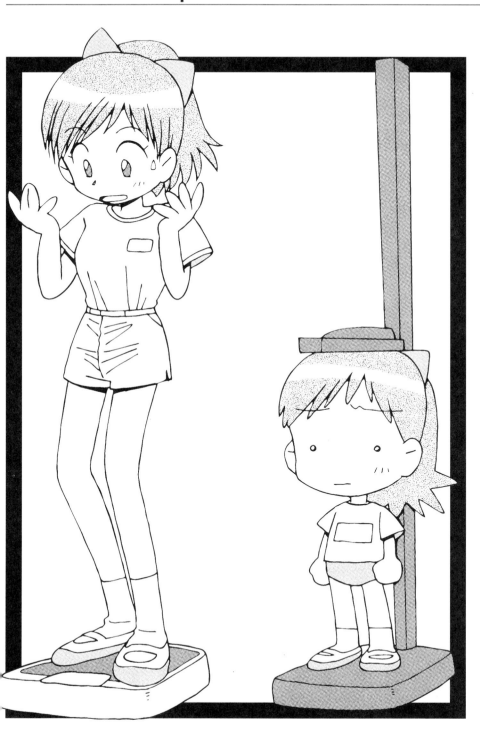

This is a "Super-deformed Character"

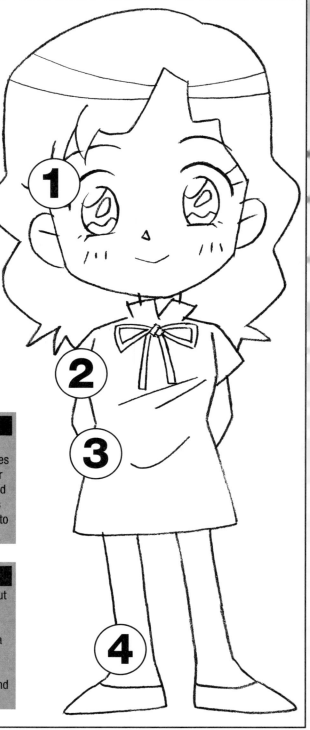

Female Characters

The Hair and Eyes (Irises and Pupils)

The hair is a human figure's most easily modifiable feature. Make certain you have properly positioned the "skull" and drawn a plausible head. Then no matter what shape you select for the hair, it will still constitute an extremely major feature for identifying the character in silhouette, even though the head has been exaggerated. Likewise, the eyes are also a key feature used to bring out a character's individuality.

The Chest

The chest constitutes a maternal symbol. Thus, it is often used to distinguish female from male characters. However, such gender differences are not so absolute in super-deformed characters, but rather are often used to suggest the character as an individual. If you insist on always giving your female characters large breasts, you may prevent yourself from ever being able to draw out a character's individuality and may find your work accused of being sexist in nature (wry laugh).

The Waist

The waist, like the chest, is often used to distinguish between the sexes. However, this does not apply to those cases where a male character or girl athlete character is drawn with an inverted triangle-shaped torso. Rather, let's consider it as serving to balance out the other body parts and to suggest the character's gender or individuality.

The Legs and Feet

Stylizing the legs is an extremely difficult task but do come in a wide variety, spanning from stick legs to puffy, bulbous legs to hourglass-shaped legs. Extra care should be taken when drawing a female character's legs to achieve balance with the other body parts, as from a probability standpoint, girls are more likely to wear skirts and other clothing revealing the legs.

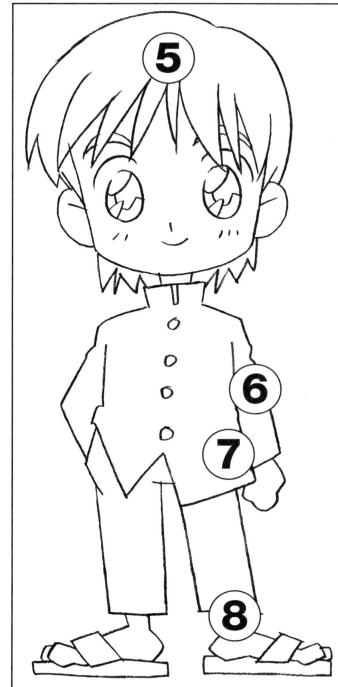

Male Characters

The Head

Super-deformed characters are usually represented with over-sized heads. However, it should be remembered that this is just one artistic technique. If you examine the contents of this technique, you will notice that characters with large heads are not always highly stylized. To restate things in simpler terms, there are also characters who are stylized that have small heads, distinguishing them as individualistic.

The Hands and Arms

As with legs discussed on the preceding page, hands and arms for male characters come in a wide variety. Naturally, degrees and methods of stylization that allow for a successful visual balance are preferable. However, in the case of some athletes or when suggesting emotional displays, the intent of the drawing is occasionally better conveyed by exaggerating disproportions.

The Trunk

The torso is actually the easiest body part to omit on a super-deformed character. Yet, this is the body part most likely to show movement before anything else when the character shifts into motion, and, therefore, perhaps it would be more appropriate to advise not to omit the trunk, but rather to abbreviate it to the simplest form possible.

The Legs and Feet

As with female characters' legs discussed on the preceding page, legs and feet for male characters come in a wide variety. However, please keep in mind that large feet oddly enough come across psychologically as more masculine than small feet. Still, we must not forget that there are male individuals who do have small feet.

Well, now we are ready to discuss abbreviating the human form, something only done in *manga* design. In fact, *manga*, itself was originally a world of "abbreviation." We find in *manga* renditions of the eyes, hands, and feet not found or simply not feasible on real-life human figures. I have never witnessed a *manga* artist present a life-like rendition of the eyes (chuckle). Consequently, those of you who have copied *manga* or produced your own works, as well as those who have read *manga* will find abbreviating easy to understand. It is my goal to see you deepen your interest and enjoyment in character stylization and incorporate it into your work or everyday drawings.

Differences between Super-deformed Characters and Realistic Drawings

Here I will illustrate (literally) the differences between a super-deformed and a realistically drawn character. Please note that use of the word "realistically" does not necessarily mean a figure drawn in heightened realism or in the style of realism *manga*. I just use it to mean your everyday, typical Dick and Jane *manga* character. Naturally, the most blatant difference would seem to be that of height; however, merely by drawing the character shorter and a little simpler will not create a super-deformed character. I will now discuss handling the various body parts and figure proportions to demonstrate my point.

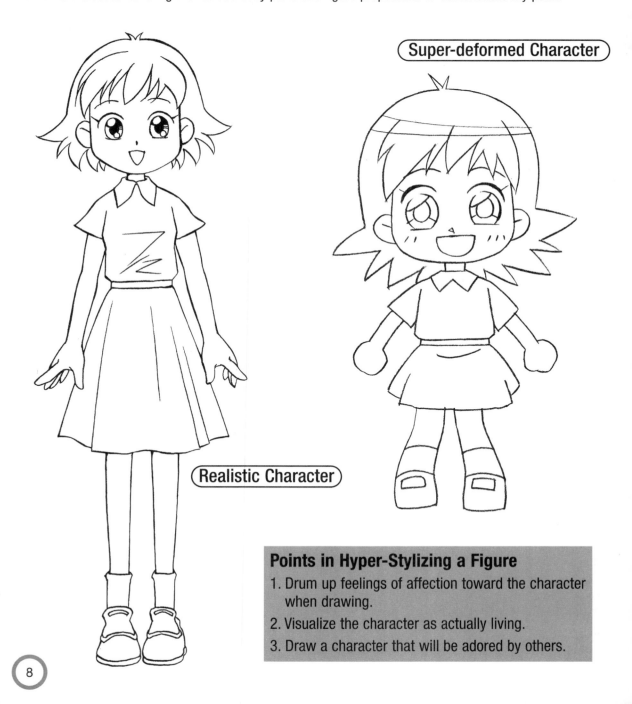

Super-deformed Character

Realistic Character

Points in Hyper-Stylizing a Figure
1. Drum up feelings of affection toward the character when drawing.
2. Visualize the character as actually living.
3. Draw a character that will be adored by others.

To portray a character in motion, use a 4:1 head-to-body ratio

Setting aside discussion on stylizing characters for now, beginning artists like yourself often encounter difficulties in achieving a satisfying pose when trying to draw a character in motion. So, what should you do in such circumstances? A popular technique is to decrease the head-to-body ratio (i.e. increase the number of heads to body). This makes it easier for the body parts to move at their joints, allowing you to create all sorts of poses. I discuss this topic in depth in another chapter. Please visit that chapter for more information.

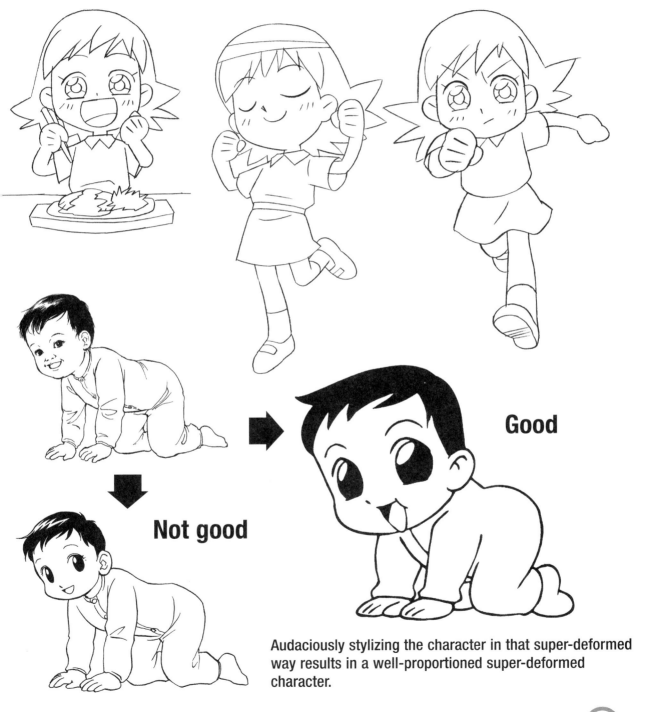

Good

Not good

Audaciously stylizing the character in that super-deformed way results in a well-proportioned super-deformed character.

Developing Characteristic Characters

Searching for Distinguishing Facial Features

We humans have many distinguishing features. If you, the artist, identify these features and exploit them when drawing super-deformed and stylized characters, you will successfully create distinctive characters. While having a model or reference figure in front of you certainly helps identify these distinguishing features, picturing an imaginary person in your mind and then searching for these identifying features will also make character design easier.

An artist's mental reproduction of a model comes out most strongly when finally put to paper or canvas, so you will create a more satisfying character if you stress your own impressions of the model's physical appearance rather than looking for outside sources of information or seeking others' opinions. You are the one who ultimately gives birth to this character, who is supposed to be imbued with appeal. Therefore, you should be the one who knows this character best.

Of course, even with a model or reference picture on hand, different features will strike each artist in a unique way. Therefore, you, as an individual artist should emphasize those features that have the greatest impact on you personally.

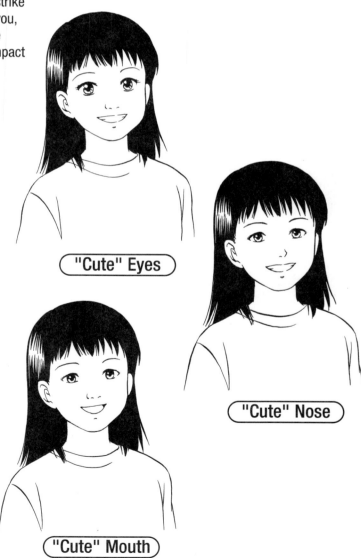

Ref. Fig.

"Cute" Eyes

"Cute" Nose

"Cute" Mouth

Assorted Eyes

Standard Eye

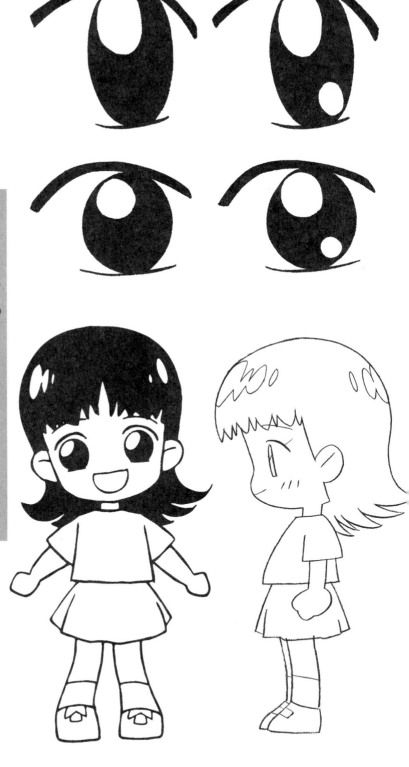

Light Reflections/Highlights in the Eye

Here we see several sample eyes with various light reflection patterns. If you look at them, you will realize they each leave a different impression. In actuality, various forms of light: direct, indirect, reflected, are cast off the eyes. Added to that are shadows created by the eyelids over the eyes, resulting in the artist needed to include an intricate play of light and shadow when drawing. Naturally, omitting highlights and reflected light, as illustrated in the eye below, also leave their own distinct impression, so it is critical that you, the artist, experiment with various different light reflection patterns—and even with a lack of light reflections all together— to see what impressions you can create by using light sources from different directions.

Eye without Highlights

Body Builds

One would also expect to find many people who have distinctive builds, even though they may lack idiosyncratic facial features. Stressing idiosyncrasies in their builds and adjusting the face to match the body will enhance your character's distinctiveness.

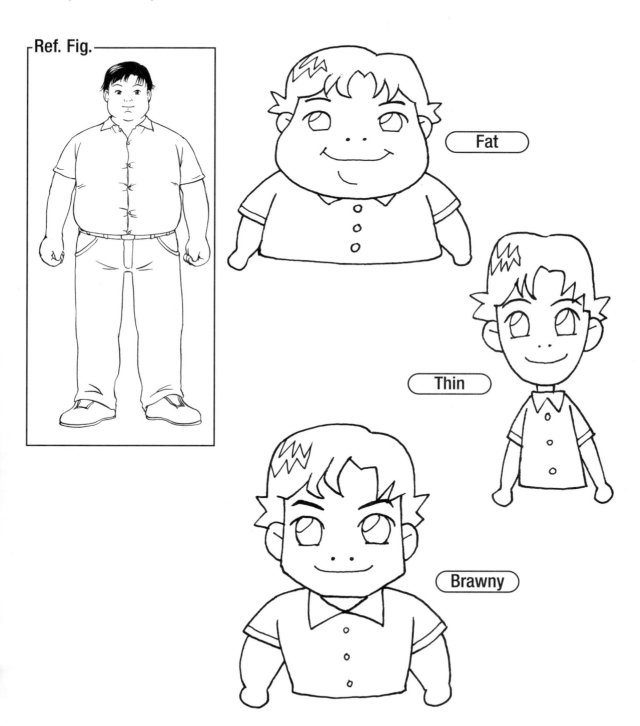

Ref. Fig.

Fat

Thin

Brawny

Hefty Builds

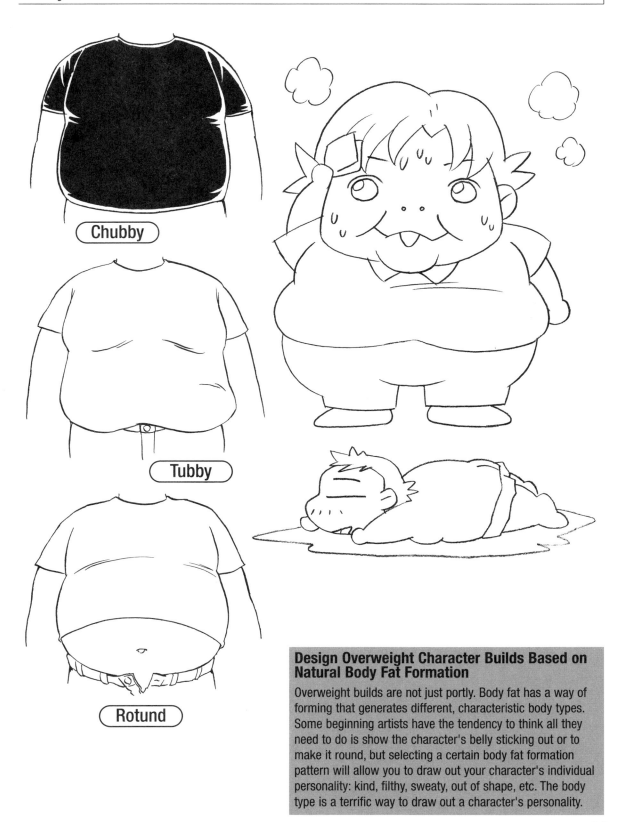

Chubby

Tubby

Rotund

Design Overweight Character Builds Based on Natural Body Fat Formation

Overweight builds are not just portly. Body fat has a way of forming that generates different, characteristic body types. Some beginning artists have the tendency to think all they need to do is show the character's belly sticking out or to make it round, but selecting a certain body fat formation pattern will allow you to draw out your character's individual personality: kind, filthy, sweaty, out of shape, etc. The body type is a terrific way to draw out a character's personality.

Using Stylization to Bring out Character Idiosyncrasies

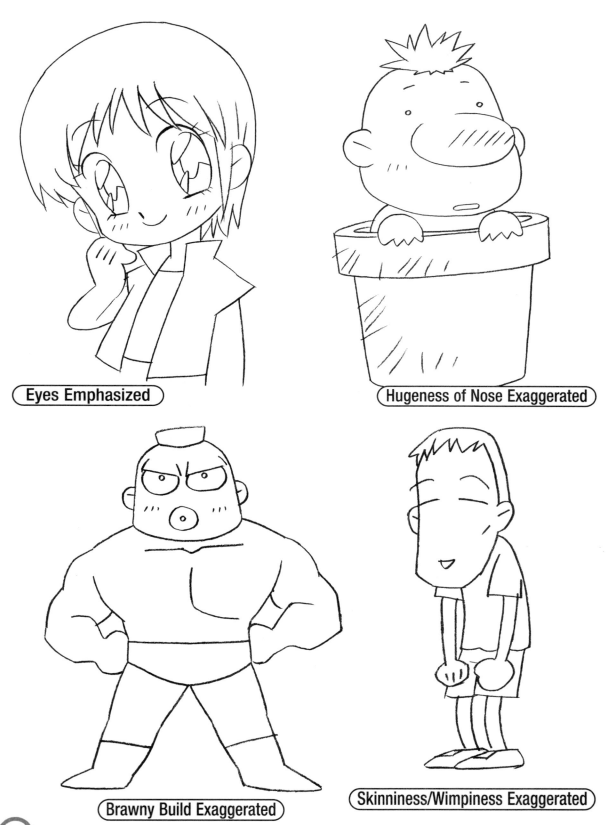

Eyes Emphasized

Hugeness of Nose Exaggerated

Brawny Build Exaggerated

Skinniness/Wimpiness Exaggerated

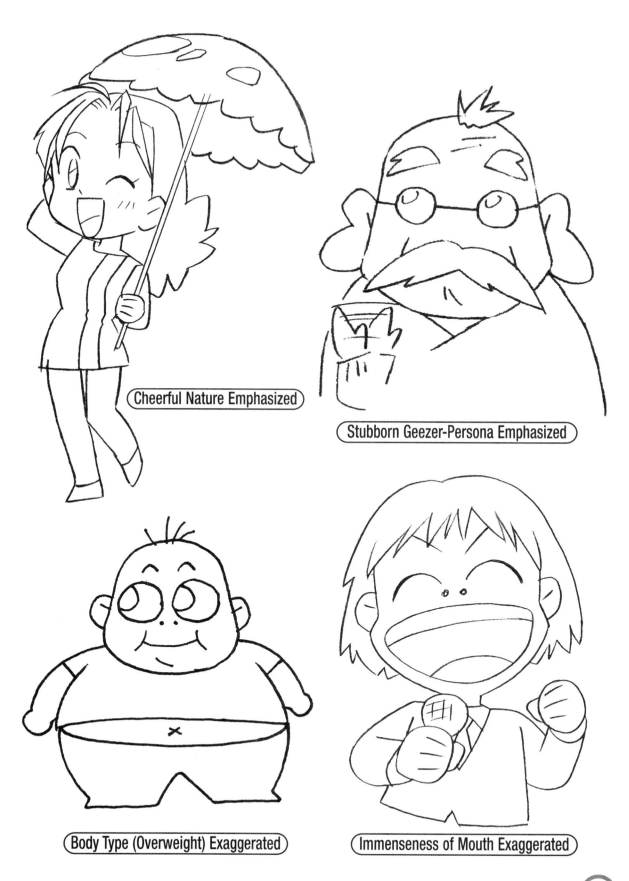

Cheerful Nature Emphasized

Stubborn Geezer-Persona Emphasized

Body Type (Overweight) Exaggerated

Immenseness of Mouth Exaggerated

In-Depth Look
The History of Super-deformed Characters

⚪ ⚫ ⚪

The origins of *manga* are regarded as traceable back to the *Choju giga* handscrolls (a Buddhist satirical work whose title is roughly translated as "Scrolls of Frolicking Birds and Animals").

While these scrolls show birds and animals anthropomorphized and anticking like humans, we are also able to visit the zoo and observe animals mimicking human behavior or moving in a manner reminiscent of humans.

Many enjoy those qualities where animals overlap with humans, and the artist creating the *Choju giga* might have been similarly inspired.

Manga is an extension of that sentiment. Artists wondering "Wouldn't it be great if something like this could happen?" or, "This would make an interesting situation," and using people to create these situations can be credited with *manga* in its present form. Consequently, we find *shoujo manga* characters with stars twinkling in their eyes and other improbable scenes. It should be noted, however, that these stars represent the artist's yearning, "Wouldn't something like this be pretty?" in emphasized form.

Yet as one might expect, exaggerated renderings have their

limits, and exceeding those limits can result in the viewer losing the ability to recognize just what your artwork is supposed to represent.

For example, deviating from 4-limbs, upper and lower body proportions, head, and other standard body part numbers and positions may cause your characters to diverge somewhat from what we recognize as human, provided we are still viewing them in a *manga* context.

The appeal of *manga* would seem to reside in how figures may be distorted within these set boundaries. Accordingly, stylization is a technique that has existed in *manga*

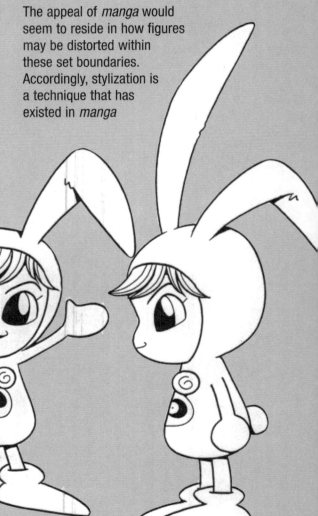

since its inception, and even the most representational "realism *manga*" still contains elements of stylization. *Manga* does have a long history, but just when was it that stylized characters marketed as designs and commercial products gain popularity?

The Japanese word "*deformé*" meaning "stylization" first came into use around the time of the hit anime "*Uchu senkan yamato*" (Space Battleship Yamato).

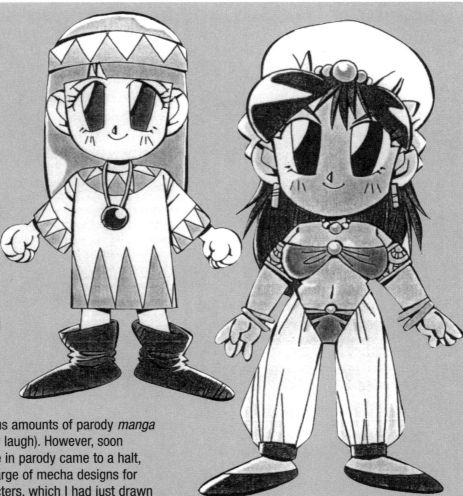

I, myself, drew copious amounts of parody *manga* around that time (wry laugh). However, soon afterwards, this surge in parody came to a halt, and I had been in charge of mecha designs for stylized anime characters, which I had just drawn as a lark, caught the attention of a toy manufacturer, and these became the first stylized characters to be sold in product form.

These products were dubbed the "Q Robo" (Q Robot) series, and I contributed the designs of various stylized characters to be transformed into gumball machine prizes sold by the same toy manufacturer. These characters-turned-gumball-machine-prizes include Q Robo Gog and Q Robo Garian, as well as other ultra-stylized anime robot toys.

Several years after the Q Robo series, another toy manufacturer launched a new SD project. At the time, most of my work was dedicated to the Q Robo series, so I was unable to participate in the launching of this SD; however, I did later join the

SD project, and created a significant number of stylized designs connected to the "Gundam" series. I was later employed as head of a different project involving stylized characters under the same toy manufacturer, which enabled me to work on stylized designs for products, product logos, and other matters unrelated to *manga* or anime, and I continue such work today.

It is owing to this legacy of stylization that the previously disparaged parody and stylized artwork gained their deserved respect and now enjoy recognition from many *manga* and anime aficionados.

Now, 27 years after I began my own stylized artwork, I have been entrusted with the writing of this book.

In-Depth Look
Meditations on the Word "Moe"

Japanese *manga* fans refer to favorite characters or characters for which they have particular affection as "moe kyara" [moe character]. In the worlds of *manga* and anime, "moe" is used qualitatively to mean "cute" or "adorable." In addition to this sense of "cuteness," "moe" can also indicate strong feelings of affection by the creator towards the character. [Note: the word "moe" literally means "budding" or "sprouting" and is also a popular girl's name.]

Drawing "super-deformed" characters requires that the artist use highly stylized proportions for the head-to-body ratio. The artist generally will make those characters he or she has imparted with particular affection and care especially charming and delightful, and I personally find

these characters extra fun from both a creator and viewer's perspectives.

Just as people say the *manga* artist is like a parent giving birth to the characters he or she creates, likewise, the characters you create are like living creatures, and showering them in love and tenderness will make them shine even more off the comic book page.

Consequently, whenever I create a character, I am always thinking to myself, "Gosh, he/she is cute!" Some of you may feel an "adult" head-to-body ratio should be perfectly fine for stylizing a character, but the truth is that it is just easier to project such tender feelings on a childlike character more so than on an adult-like one.

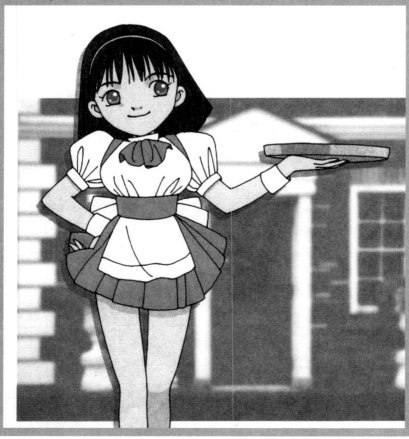

Chapter 2

○○○○○○

Super-deformed Building Blocks: The Face and Body

Check out the mix-and-match found on page 122 at the end of this book!

What a Face!

The face plays a very important part of character design. In the case of a super-deformed character, the face should be something that the viewer will find disarming and evokes protective instincts. To put it simply, a super-deformed character is one that contains many elements that will elicit feelings of fondness in the viewer. Accordingly, the way each individual facial feature is rendered becomes very important.

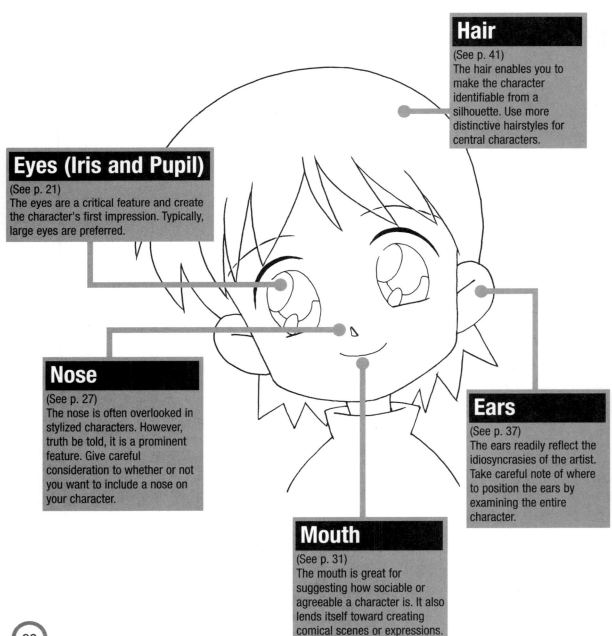

Hair

(See p. 41)
The hair enables you to make the character identifiable from a silhouette. Use more distinctive hairstyles for central characters.

Eyes (Iris and Pupil)

(See p. 21)
The eyes are a critical feature and create the character's first impression. Typically, large eyes are preferred.

Nose

(See p. 27)
The nose is often overlooked in stylized characters. However, truth be told, it is a prominent feature. Give careful consideration to whether or not you want to include a nose on your character.

Ears

(See p. 37)
The ears readily reflect the idiosyncrasies of the artist. Take careful note of where to position the ears by examining the entire character.

Mouth

(See p. 31)
The mouth is great for suggesting how sociable or agreeable a character is. It also lends itself toward creating comical scenes or expressions.

The Eyes Bring Life to the Character

Eyes are extremely individualistic, varying from person to person, just as the eyes of Asians versus non-Asians differ. It is believed that most individuals can be distinguished simply by viewing their eyes and facial outline. Let's look at a number of different prototypes for drawing the eyes.

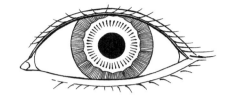

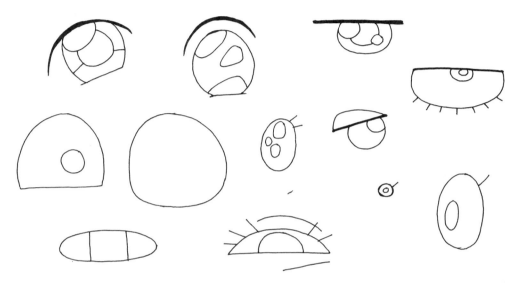

Popular Eye Expressions

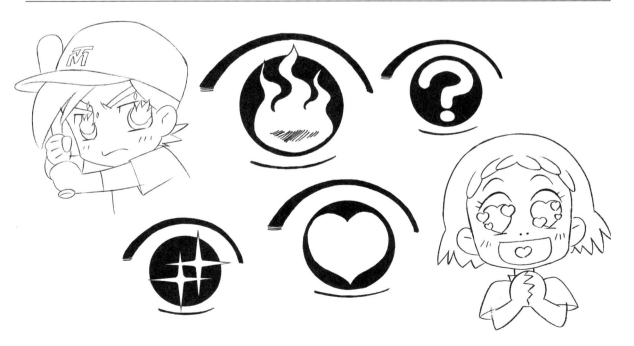

Remember: There Is More to the Eye Than Pupil and White

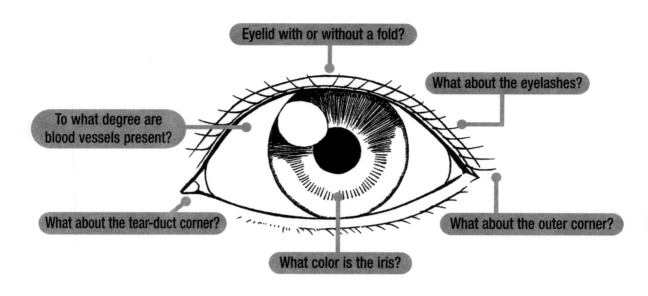

Eyelid with or without a fold?

What about the eyelashes?

To what degree are blood vessels present?

What about the tear-duct corner?

What color is the iris?

What about the outer corner?

(**Eye Fold or No Eye Fold**)

(**Eyelashes Emphasized**)

(**Eye with White Exposed Underneath and to the Sides**)

(**Wrinkles Emphasized**)

By giving particular emphasis to the various eye components in this manner, you will be able to imbue your character with individuality. You'll also have lots of fun exploring the different moods projected by modifying how these different components are portrayed.

Drawing Memorable Eyes

Let's see how the eyes introduced on the previous page look on a face. While the irises have been handled the same for all, note how each treatment of the eye makes each face look like a wholly new character.

By all means, play around with the bonus mix-and-match found on page 122!

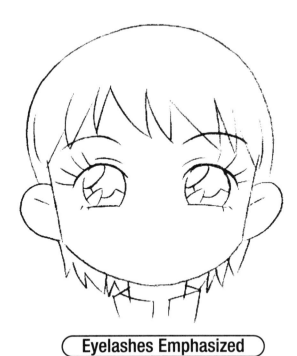

Eyelashes Emphasized

Eye Fold Emphasized

Eye Wrinkles Emphasized

Make the Eyes Expressive

Once you have acquired an understanding of basic eye rendition, the next task you will need to address is how many different expressions you can suggest using the eyes. It is important that you analyze the eye's various components and learn how to stylize these components to embellish a given facial expression. Play around with exaggerating the individual eye components (e.g. the inner corner, the outer corner, the eyelid, etc.) to see which expressions you create.

When using the eyes to suggest "laughter" or "happiness," having the outer corner of the eyes turn down will give them a hint of warmth. To exaggerate the look of the outer corner turning down, the inner corner must also turn down, creating an arch. This look has become the standard in character stylization. Differences in the angle and size of this arch can produce subtleties in expression, so the best that I can suggest is for you to practice drawing yourself.

To suggest "anger," usually not only is the eye drawn as "angry" but the eyebrows are as well, owing to their relationship with the surrounding eye muscles. However, the eyes themselves actually change shape when they are pushed downward by the eyebrow muscles, which causes the upper arc of the eyelid to change. When stylizing a character, the subtle change in the upper eyelids is magnified. Simply put, remember that "scary eyes" mean "anger."

To suggest "sadness" or "crying," as with anger, the eyes actually change very little: the eyebrows lose their tension, causing them to shift downward and either come into contact with or approach the eyelids. While no change actually occurs in the eyes themselves, since this emotion is tied to a psychological jolt, the irises should be imbued with a drained feel. Show the eyes directed either up or down, as if to suggest the character is unable to meet another's gaze. This will create the desired mood. Please also refer to the section on eyebrows, where they are discussed separately.

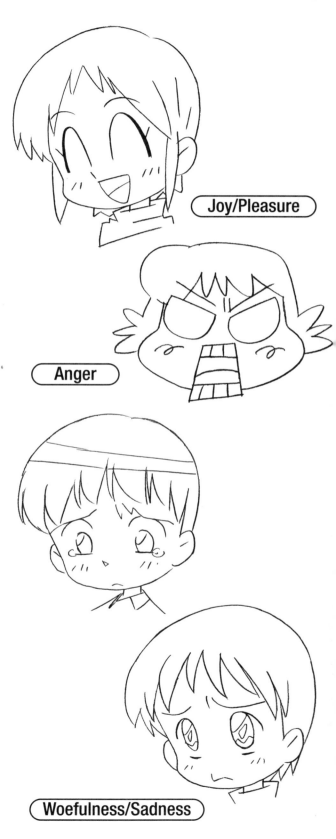

Joy/Pleasure

Anger

Woefulness/Sadness

Flamboyant Faces

Eye expressions not physically possible in the real world are often frequently found in stylized artwork. For example, eyes so large, they extend beyond the facial outline, tears pouring out of eyes like a waterfall, X-mark used in lieu of drawing eyes, or shapes totally in disregard of musculature. As I mentioned earlier, these are the results of embellishing subtle movements in parts of the eyes or face when suggesting an emotion.

It said that today we live in an impassive age. However, I would ask that you please pay careful attention to which parts of the eye move and how when you draw emotional reactions.

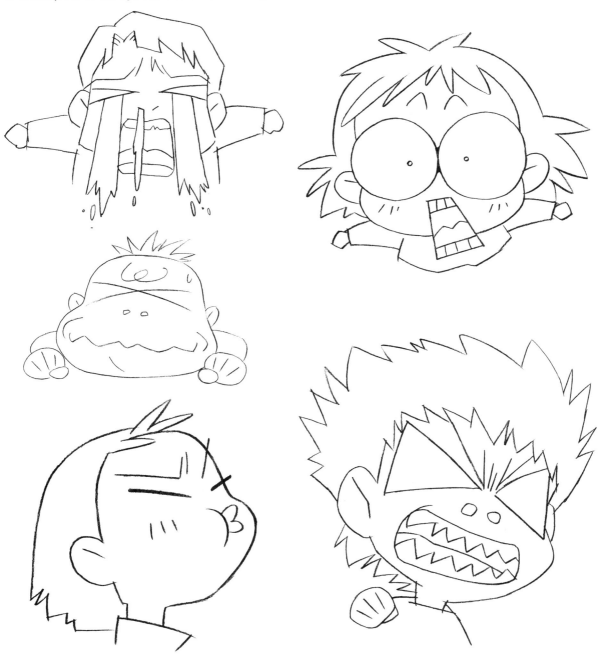

Short Lesson
Are the eyebrows more expressive than the mouth?
○ ● ○

Beginning artists will need to understand that eyebrows are not merely "lines."

During the course of my work, I often see students' and young *manga* artists' work and have noticed that as of late that eyebrows are being less and less used to suggest emotion. Now, I do realize that plucked eyebrows are all the rage in Japan for both men and women, so using simple lines to render the eyebrows might be reasonable from a stylization standpoint. However, the truth is that this lack of individuality is detrimental to *manga* culture. Make a distinction in your mind between pop culture trends and individuality while you are still young and learn about the differences.

The eyebrows are highly expressive of individuality, regardless of whether the character is male or female. You might notice that in the case of super-deformed characters, the eyebrows are even more expressive than the mouth.

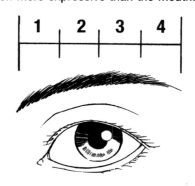

Extreme Emotional Reactions

Friendly Friendlier

Widen the distance between the eyebrows.

Angry Angrier

Concerned More concerned

The eyebrows overall are lowered and drawn touching the eyes. Generate a look of tension on the brow.

Assorted Eyebrows

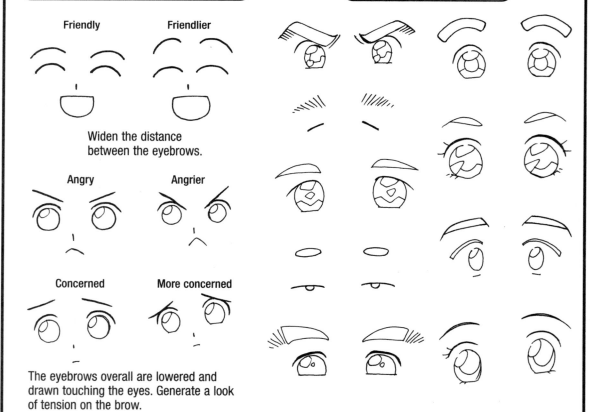

Noses Stick Out

○ ● ○ ──────────────────

Searching for Distinguishing Facial Features

Artists drawing in a stylized manner often disregard noses. However, there are many people running around with distinctive noses, and you, the artist have a responsibility to exploit such traits or risk your carefully planned stylized characters losing flavor. The nose is a superb feature for suggesting the character's occupation (e.g. a police inspector in the style of Osamu Tezuka, or a student, private investigator, etc.), projecting a friendly impression, or generating a distrustful air. Noses are wonderful for portraying a character.

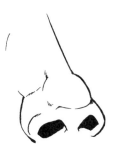

Likable Noses

Large, round noses project a kindly impression.

Detestable Nose

Large, angular noses seem eerie and strike the viewer with fear.

Sports Easily Portrayed through the Nose

The Everyday Boxer's Nose
A large nose results from the boxer taking a lot of punches in the nose, indicating this guy is rather mediocre. Alternatively, this nose could portray a beefy, strong boxer.

The Talented Boxer's Nose
A small nose suggests this boxer is good at avoiding punches, indicating this guy's got skills.

Small Noses

Use small noses for women and girls to give them a feminine look. Conversely, large noses project a stronger, masculine air.

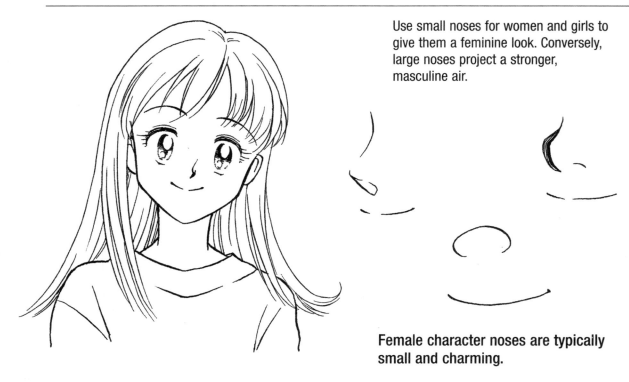

Female character noses are typically small and charming.

Symbols Representing the Nose

Like the eyes, the nose is a highly individualistic facial feature. When drawing a face, the key is to have one overplay the other. Drawing both equally expressive would cause a visual conflict. The two features would vie for the viewer's attention, canceling each other out.

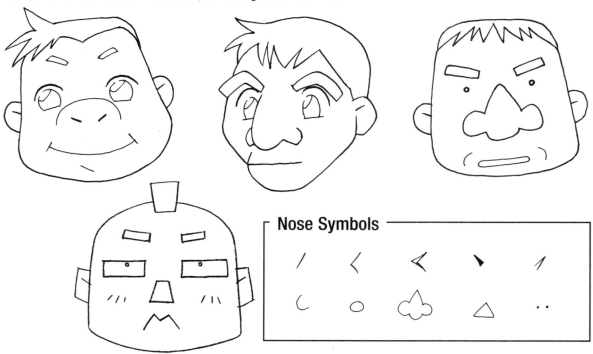

Nose Symbols

Expressing with the Nose

While the nose does not actually move, it does change color and emit interesting body fluids. Exaggerating these qualities will allow you to express emotion. For example, add a little red on the upper part of the nose to suggest embarrassment or awkwardness or red to the tip of the nose to underscore that a character is in a drunken state.

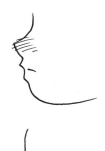

Up to now, we have been discussing the nose's outer contours; however, like the eyes' tears, the nose has other possibilities of portrayal.

First of all, there's color. Noses tend to redden, depending on the situation: when we are embarrassed, drunk, fall down and bump our noses, etc. However, you need to distinguish between the different reasons for the nose reddening when stylizing this phenomenon, or your nose will appear awkward. Furthermore, this will also change when the nose is drawn exaggeratedly large or small. Perhaps these points are better explained through pictures rather than words.

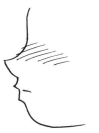

In addition, for whatever medical reason, noses are often spotted with pimples and other blemishes. Perhaps it is because the nose pores, which are larger and more visible than those on the other facial features, tend to secrete in large amounts, inviting bacteria to enter. Whichever the case, blemishes can be used when stylizing the nose to draw out the character's individuality.

While depictions of runny noses have been disappearing from *manga* of late, they are a standard way of suggesting childishness or childlikeness. Take care in that overdoing a runny nose could just make your character look like a dufus.

When suggesting that a character is angry or ready for a fight, the nose is often depicted snorting. There is the tendency to give snorted air a smoke-like look as if it were a tailpipe emitting gas, which is why professional artists often also will exaggerate the nostrils, showing the snort broadening out from them.

Embarrassment/Shyness

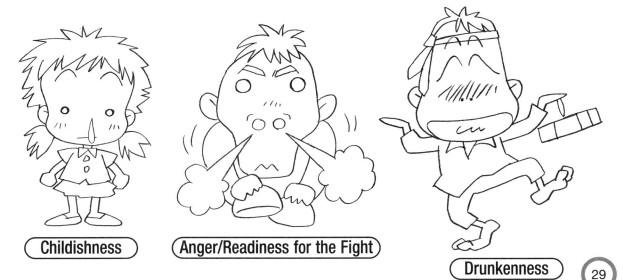

Childishness

Anger/Readiness for the Fight

Drunkenness

29

Short Lesson
Giving the Face 3-Dimensionality, Even with Minus the Nose

Artists often omit the nose when drawing stylized characters, but this is not necessarily always the case, since many noses have personality. While characters without noses are perfectly acceptable, please note that there is a large difference between characters without noses and characters who appear not to have noses.

Characters without noses become distinctive personalities owing to their lack of noses. Consequently, they should be drawn in profile without a nose, so take extra care to ensure that such a character clearly has no nose in profile. In such cases, you will still have to give that

character's face 3-dimensionality. When drawing a head that is roundish all over, be conscious that what you are drawing is not the same as an actual human skull.

If the nose is not visible from a front view, then omit it from the profile as well.

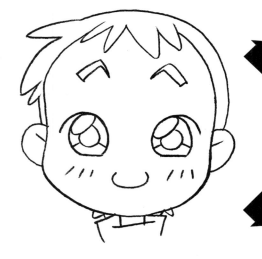

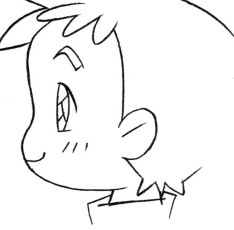

If you have given proper consideration toward making your character 3-dimensional from all views, then you should be able to rotate her.

The Agile, Moving Mouth

Of all the facial features, the mouth changes shape the most owing to the surrounding muscles. As you are aware, we humans use words to convey our wishes to others, and the mouth engages in movement whenever this occurs. Accordingly, the mouth takes on many forms and is a prime feature for suggesting the sociability or agreeability of a character.

Various Mouths

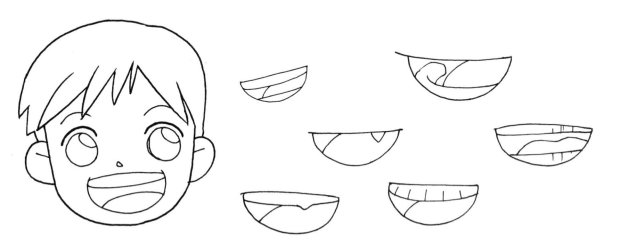

Cross-Sectional View

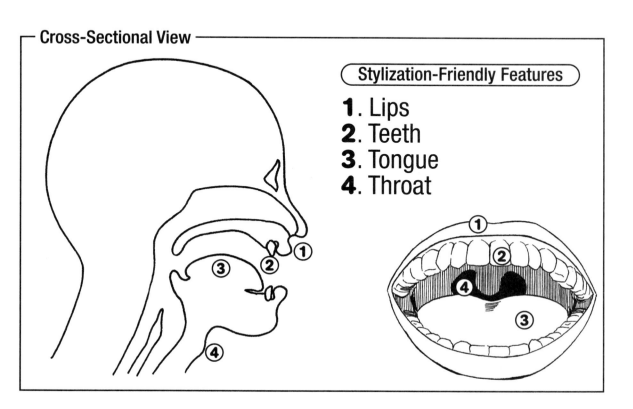

Stylization-Friendly Features

1. Lips
2. Teeth
3. Tongue
4. Throat

Assorted Mouths

Lower Teeth + Tongue

Not used much other than for special circumstances

Vampire Teeth

Not exclusive to monsters, these may also be used to illustrate a character's personality.

Decayed/Missing Teeth + Tongue

Used with children and comical characters

Exaggerated Canine Teeth

Used to add to a character's distinctiveness

Emphasizing Upper Teeth

A popular way of rendering the mouth used to emphasize joy when smiling, etc.

Missing Tooth

Used to add to a comical character's personality

Devising Unique Mouths

Closed Mouth

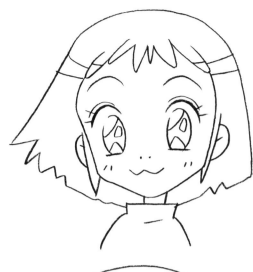

Open Mouth 1

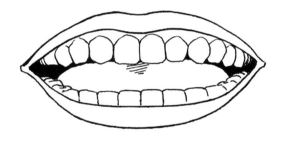

Open Mouth 2

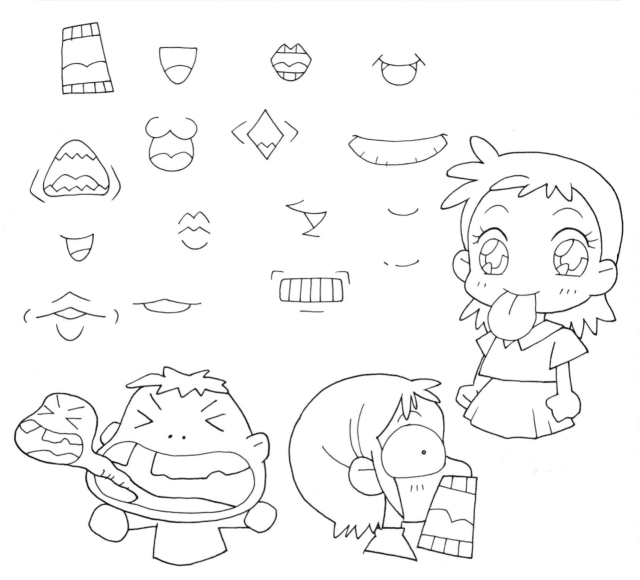

Let's consider how to render the individual mouth components. When imagining these three: the lips, the teeth, and the tongue, think about what would catch your attention about the mouth if the character you are about to draw actually existed and you were to sit face-to-face with her.

Do the teeth catch your attention? Or is it the tongue? The picture in your mind's eye will become critical when you draw the character. In particular, the lips are a flexible feature, and consequently can take on a number of shapes. Naturally, physically impossible shapes are also acceptable in the case of stylized characters. However, care should be taken to avoid overdoing reactions, which could result in destroying the face's or figure's proportional balance.

The teeth also offer a multitude of possibilities. Artists have the tendency to go into autopilot when creating stylized characters to draw a single line underneath the upper lip and call it quits. However, teeth are not just teeth. We have incisors, canines, molars, upper teeth, lower teeth, etc.

Mouth Expressions

Using Combinations to Boost Expressions

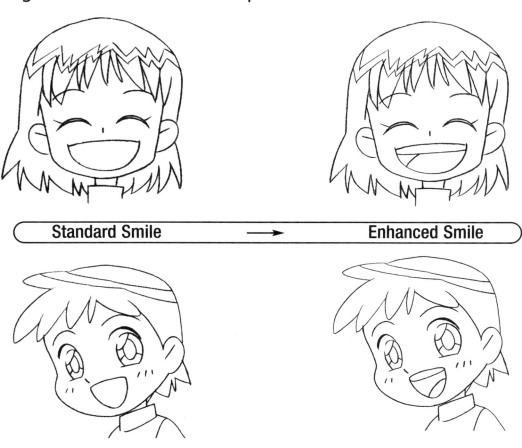

Standard Smile → Enhanced Smile

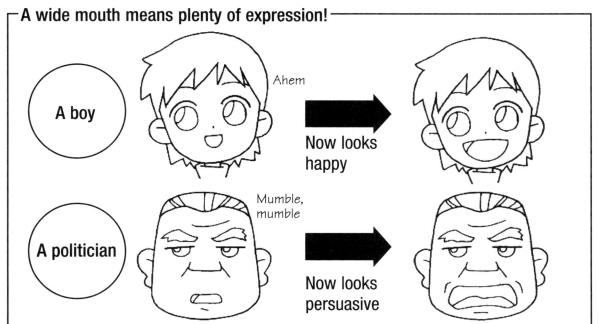

A wide mouth means plenty of expression!

A boy — Ahem → Now looks happy

A politician — Mumble, mumble → Now looks persuasive

In-Depth Look
What Do Those Lines and Dashes on a Character's Face Represent?

We often find multiple lines on a stylized character's cheeks, but what exactly do they mean?

Many might mention the lines appearing in childhood scenes on the cheeks of Hyuma Hoshi, the lead character of the *manga* series *Kyojin no hoshi* (Star of the Giants); however, I believe that the creator has never actually stated publicly exactly what they are. (well, perhaps it was mentioned at some time [wry laugh]). At this point in time, we really cannot confirm what they represented; however, we can discuss lines I have used on my own super-deformed and stylized characters' cheeks. There are several actual possibilities for what they represent.

As you have learnt from our discussion, super-deformed and stylized characters are composed of omissions and symbolizations of body parts. Thus, you probably realize that these lines represent "something" that has either been left our or has been abstracted to symbolic form. Well then, just what exactly could this "something" be? In the case of a small child or baby, it is known as "cheek blush."

In the case of a child who has grown to some extent, these lines more likely are being used to suggest 3-dimensionality in the face. Therefore, when drawing a small child as mentioned above, add several light lines to the center of the cheeks. When drawing an older character, whose facial features stick out more, add a few lines slightly high of center to the cheeks.

Many readers may have felt that these lines held no particular meaning, but in actuality they did hold these special significances.

> Lines (dashes) on a character's face change depending on the age.

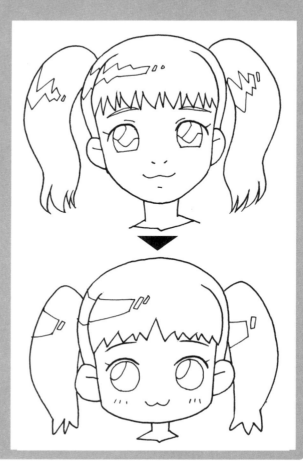

The Ears Reflect the Artist's Personality

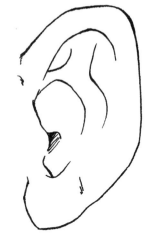

Many tend to assume that the ear is the part most difficult to distinguish the character's individuality and is something to be hidden behind the hair. However, there are others who see an ear and think, "Look! That's definitely an (Artist X) ear."

Well then, it is certainly true that the ear is not the idea body part for illustrating a character's personality or behavior, but it is that which reflects the idiosyncrasies of the artist the best.

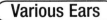

Various Ears

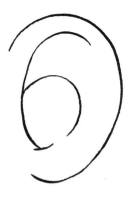 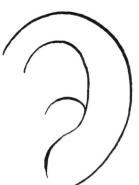 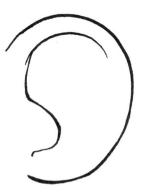

When you start out, use the ears of an artist you like as reference.

For eyeglasses, position the ears to maintain overall balance

With respect to stylized characters' ears, there is no need to take as much care when drawing as you might with a regular sketch. However, glasses pose a serious issue. You need to take care to position the ears so that a character in glasses will not appear awkward. The ears are usually centered along the face's outer contours.

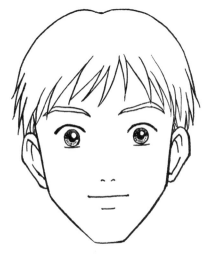 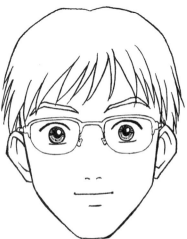

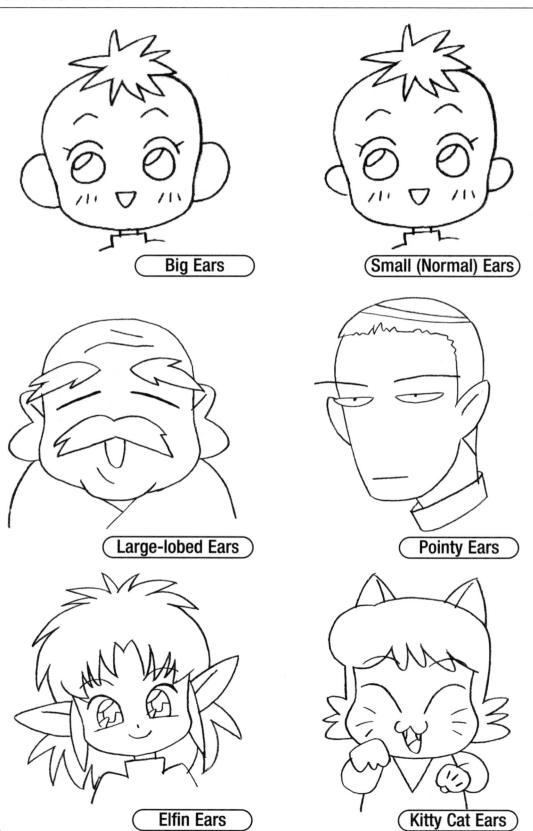

Big Ears

Small (Normal) Ears

Large-lobed Ears

Pointy Ears

Elfin Ears

Kitty Cat Ears

The Ears Are Here!

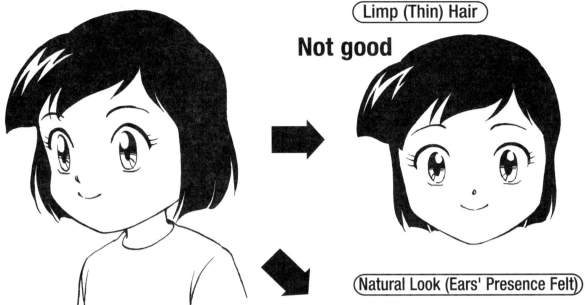

Limp (Thin) Hair

Not good

Artists have the tendency, particularly with female characters, to hide the ears under the hair. Make an effort to allow the ears' presence to be evident, even if they will not be visible.

Natural Look (Ears' Presence Felt)

Good

Hiding Elfin Ears

The ears can be hidden behind the hair, which allows a character to conceal physical oddities from others. This is a fantastic technique both dramatically and in story building.

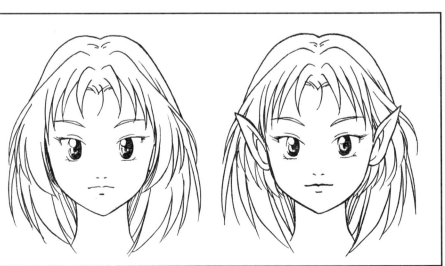

Ear Expressions

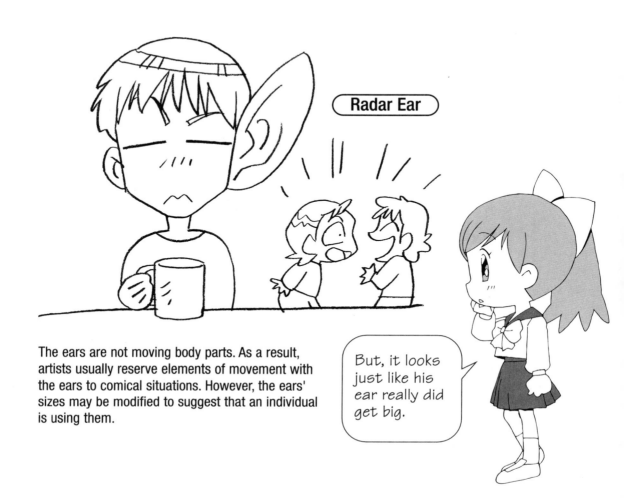

Radar Ear

The ears are not moving body parts. As a result, artists usually reserve elements of movement with the ears to comical situations. However, the ears' sizes may be modified to suggest that an individual is using them.

But, it looks just like his ear really did get big.

On elderly characters, large-lobed ears create a gentle, kindly look

Oddly enough, one rarely sees young people in *manga* or book illustrations, etc. with large earlobes. For some reason or other, large lobes seem to be commonly used to represent elderly characters. This could very well be an example of stylization using people's preconceptions to generate a stereotypical look.

Hairstyles and Distinctive Silhouettes

We can greatly modify our hair to suit our personal preferences by cutting it, tying it up, or dyeing it. Thus, the hair is a great feature for individualizing a character.

Take a look at the hairdos of the lead characters in *Ge ge ge no Kitaro*, *Dragonball*, etc. and try to devise an original hairstyle of your own.

Assorted Hairstyles

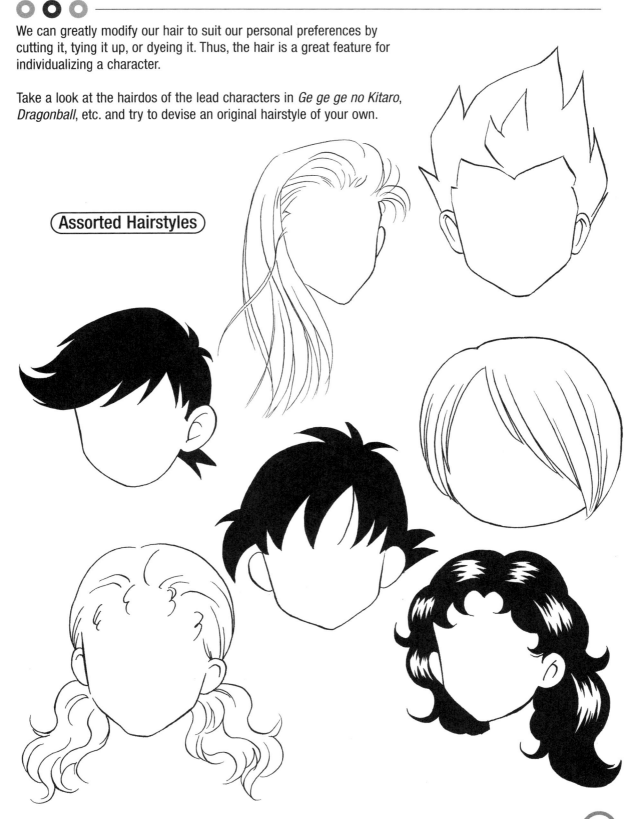

Distinguishing Characters' Silhouettes Using Hairstyles

When designing the hair of a stylized character, what you should ask yourself is not how you want to tie up the hair but rather what sort of shape (of the outer contours) you want to result. Don't worry about how to tie back the hair realistically to create a certain shape. Remember, the character could always wear a hairpiece or extensions.

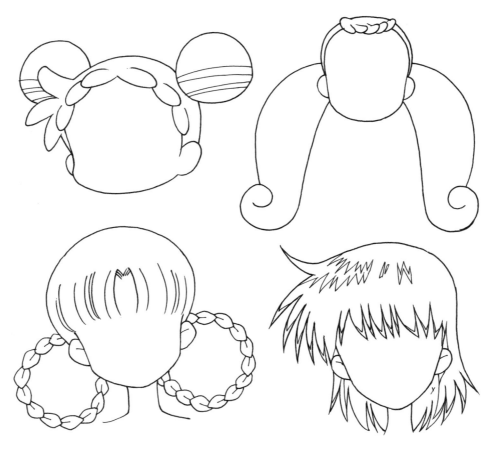

Characters cannot be made distinguishable using color, grey value, or screen tone

Modifying the color of a character's clothing or hair becomes meaningless in dark settings or under special lighting. Consequently, avoid worrying about color or grey value if you want to emphasize individuality in your character design (the same applies to screen tone).

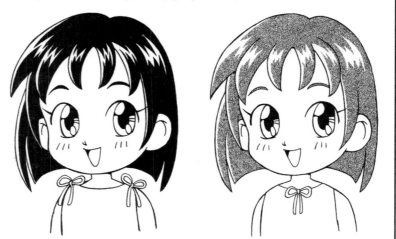

In-Depth Look
The Importance of the Silhouette 1
⚪⚫⚪

Now, let's get back to our topic. How do we identify a friend who is approaching from far? What elements allow us to identify him or her? Some of us have good eyesight, and others, bad. Some may call out. Still, most of us use information in the silhouette to identify our friend.

Take a look at Fig. A. If you were asked to identify a particular character amongst the silhouettes below, could you find your target? Probably not.

Next, look at the group in Fig. B. Perhaps this goes without saying, but chances are at some time you will need to draw a character's shadow or back view.

What would happen if all that appeared of the characters was something like that in Fig. A? This would likely be a *manga* night scene or back shots of the characters, where it would be difficult to identify individuals. Imagining situations like this illustrates just how important the silhouette is. Given that interior facial features have little effect on the outer contours, the character's individuality arises from the hairstyle's intrinsic recognizability.

Accordingly, you should devise a hairdo that has a somewhat uninhibited look rather than rely on existing hairstyles. Lastly, please note that with the exception of especially established characters, I recommend that you take advantage of the various hair attributes, such as flowing in the wind.

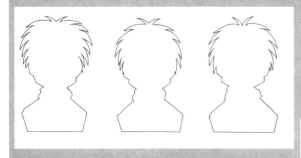

 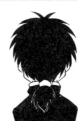

In-Depth Look
The Importance of the Silhouette 2

Recently, an abundance of artists who draw fantastic handsome men and female characters have appeared on the scene. However, the number of artists capable of drawing incredibly handsome male and exquisite female characters, but who can't turn out a properly ugly face is growing. Check out the work of renowned artists like Osamu Tezuka and Shotaro Ishinomori, who have several decades of experience in the field. It does not matter whether you like the artist or not: just look. Are these artists drawing only attractive male and female characters? Chances are that they produced many no-so-attractive characters as well, and may even have work where an attractive character does not show up at all.

This one holds true for my students as well. There are a huge number of students who still believe that drawing gorgeous characters makes their artwork appealing, so they avoid drawing less attractive characters.

But, think about it. What makes Superman "super"? Because he's here on the Earth, and he has "super" powers in comparison to the rest of us earthlings. If Superman were to return to Krypton, he would no longer be "Superman" but a regular guy.

The same holds true for attractive characters. If all of the characters are attractive, then what is the result? By comparison, they are all rendered average. What makes attractive characters attractive is that those who are not beautiful are in the majority, allowing the attractive ones to become plausible as the hero or heroine.

Yet, even amongst my students I see those who maintain the silhouette of an attractive character, merely adding blemishes or lines to the face to make the character "ugly." However, will just adding blemishes or lines to a beautiful character's face make that character ugly? It probably would not convince the viewer. Unless the character's build is redesigned, it will just appear odd.

One needs knowledge of recent, popular celebrities to draw, but familiarity with the appearance and behavior of the average guy walking down the street is ten times more necessary.

Finally, I would like to stress that characters become recognizable not when they all have similar silhouettes, but when their silhouettes are widely varied.

Occasionally, the artist will incorporate the characters' assorted backgrounds (character profiles) into their silhouettes. Conversely, the artist may first devise a silhouette and then tie that into the background. Ex.: fat character → big eater, friendly, etc.

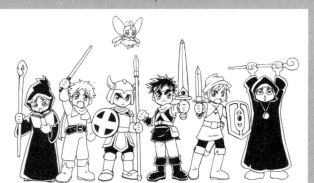

Miss

Which one is the brave hero?

 Miss

Which one is
the protagonist?

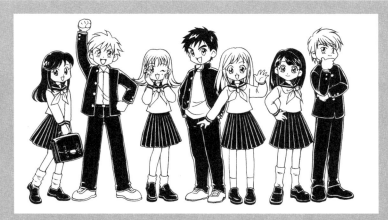

Hit

Sports-centered story

Hit

Superhero-centered story

Hit

Kid-centered story

Use a Triangle to Lay out the Face

○ ● ○ ──

Face layouts play with our instincts depending on the particular layout pattern used. For example, the size or position of the eyes could evoke parental or protective feelings in the viewer.

Well then, what other effects do we artists have at our disposal? Let's take a look at a few.

I think you'll gain some idea looking at the figures below. While there are differences in the eyes' sizes, more significant differences can be found in the triangle determining the spacing between the eyes and the angle and distance from the eyes to the nose and then to the mouth. In a glance, you can see how whether an equilateral triangle or an isosceles was used affects the character's individuality or mood projected. Play around with different triangles.

Whether a face has wide spacing between the eyes, a nose positioned high or low, large or small facial features all affect how that person is perceived. However, I feel I should warn that this does not necessarily mean that the individual's personality will match this perception. Assuming that the face perfectly matches the impression projected or personality of its wearer is prejudice. My mug is not so perfect either and could probably scare someone into thinking I'm a felon (chuckle). At the most, what we are discussing on these pages is the image projected as a *manga* character. I want all the readers to understand this as we continue our discussion.

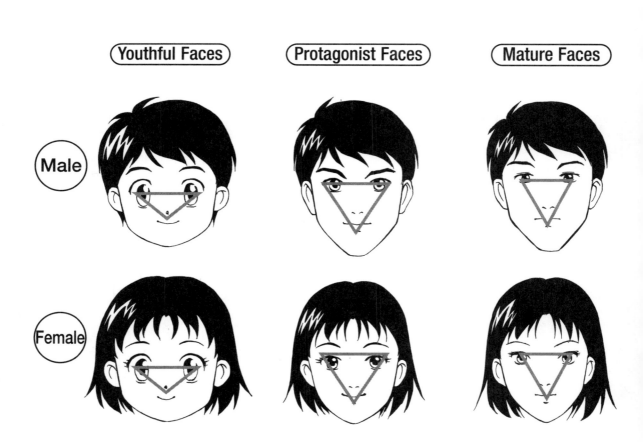

Cuteness Is Not Exclusive to Big Eyes

There is a myth floating around that drawing the eyes large will automatically make a character "cute," but is that necessarily the case? There are plenty of people in this world with small eyes who are quite adorable. This would indicate that the same would apply to drawing cute stylized characters. Hence, mastering stylization means that you should be able to create any type of character you desire, regardless of what popular beliefs might exist about character stylization.

By the same token, whether eyes give a character a sweet face or not does not depend on their size, but on their position or layout. Let's take a look at some samples.

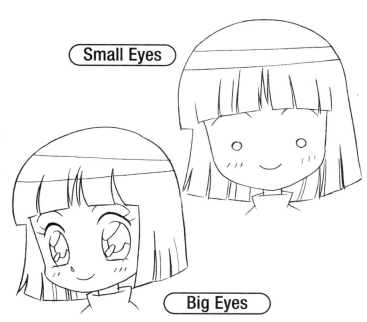

Small Eyes

Big Eyes

Proper layout makes for a delightful face

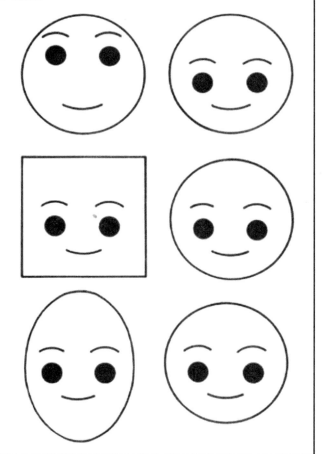

Eye Position

Drawing the eyes around the center rather than upper half of the head's outline creates a more "adorable" look.

Square vs. Round

Rounder, softer heads are more "adorable" than squarish heads.

Circle vs. Ellipse

A perfectly round rather than oval head is cuter.

Points of Caution in Drawing Super-deformed Characters

Not everything goes when drawing a stylized character. Characters must be composed according to certain rules and must be visually comprehensible.

Naturally, this excludes those cases where you intentionally raise the eye level or wreck the face's layout (only to be used in comical situations or for Picasso-style scrambled faces).

Occasionally, there are artists attempting to draw their characters in perspective in order to improve their look. However, adding perspective to a character whose head is not that large in the first place requires exceptional drawing skill and in truth, is not even necessary. Avoid concerning yourself solely with the character's appearance and adding haphazard perspective.

Planning the Degree of Stylization

Character with Mixed
Degrees of Stylization

Use symbolized noses on super-deformed characters

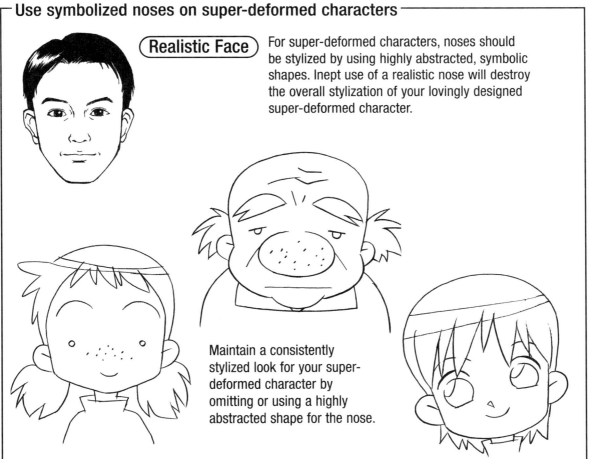

(Realistic Face)

For super-deformed characters, noses should be stylized by using highly abstracted, symbolic shapes. Inept use of a realistic nose will destroy the overall stylization of your lovingly designed super-deformed character.

Maintain a consistently stylized look for your super-deformed character by omitting or using a highly abstracted shape for the nose.

Short Lesson
Drawing Non-Japanese Characters
○ ○ ○

That one can usually distinguish the difference between a Japanese and a non-Japanese individual indicates it is possible to stylize characters' ethnicities. Use of special traits allows artists to suggest a nationality or ethnicity. While I only describe a few samples here, you will surely enjoy discovering new traits of various nationalities yourself, so I encourage you to play around.

One technique I use to distinguish between characters of Russian versus northern European extraction is to give the Russian character a hint of Mongolian. Ultimately, this decision was not based on logic but just to create a convincing air.

I give characters who are African or of African descent a cheerful disposition and make their eyes and lips prominent. Other characters may also be given hairstyles or different looks that verge from that traditionally "Japanese." However, please take care to avoid drawing a character overly dark or in such a way as to project a negative impression. Such renditions could potentially become racially discriminatory.

The non-Japanese characters appearing on this page are first and foremost those I personally felt were representative of their ethnicities, but please do not misunderstand my motives. I am not insisting that persons of these ethnicities necessarily look like what is pictured.

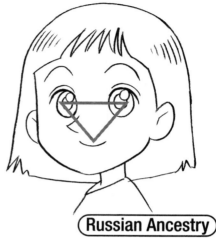

Russian Ancestry

Equilateral triangle

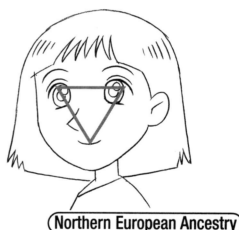

Northern European Ancestry

Isosceles triangle

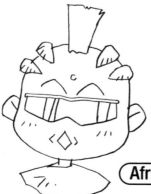

African Ancestry

In-Depth Look
Changes In Facial Layout According to Age

○●○

Everyone is aware that faces changing with age is an inevitable fact, but how many are aware of which areas of the face change and how? There are still many aspects to aging that I do not understand myself, so I find this an extremely interesting topic.

Different changes occur in men and women as the hormone balance becomes disrupting as a result of aging.

For example:
- Smoothness to the skin (Men's skin usually grows softer)
- Hair volume (Men's hair usually thins)
- Eyebrows (Men's eyebrows tend to grow longer)
- Ear hair (Men's ear hair tends to grow longer)
- Facial hair (While rare, some women do grow facial hair as they age), etc.

This does not mean that all you have to do is add a few wrinkles to the forehead, mouth, and eyes of a youthful character to convert him or her into an elderly person. There are no clear-cut techniques to suggesting age.

Preschool Age

Elementary to Middle-School Age

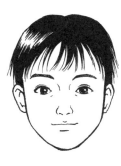 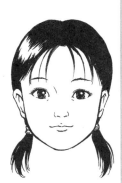

Teen to Mid-Twenties

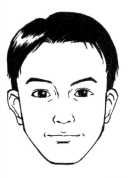 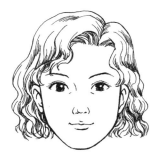

Elderly

In-Depth Look
Super-deformed Characters at High and Low Angles

Needless to say, there will come a time when you will have to draw a super-deformed character from an overhead or low angle owing to compositional reasons. You should be able to understand the issues involved without a problem if you conceive of the super-deformed character as a solid object.

What you need to remember more than anything else is that a different handling of perspective is needed when drawing *manga* characters than when drawing book illustration figures and the like. For example, suppose you are illustrating a tomato. No acknowledgment of the tomato as a solid is necessary, because it will not move or change from what you are seeing. Thus, you are able to draw it as a flat object, while giving it a fun and attractive look. Conversely, a *manga* character should be alive inside the head of the creator. Therefore, a sense of the character as a 3-dimensional object is required. Naturally, 3-dimensionality involves drawing the character in a consistent perspective as well as from various angles.

Take care to avoid the type of perspective mismatched discussed earlier. Make your super-deformed characters sparkle!

52

In-Depth Look
Shading Super-deformed Characters
○ ● ○

If you are maintaining a sense of 3-dimensionality in your drawing and a light source is present (as there will undoubtedly be), then shadows will come into play. Take note that this does not mean the traditional, realistic type of shadow, but one that will give the super-deformed character presence as a solid. Consequently, you need to comprehend the super-deformed character as a 3-dimensional object.

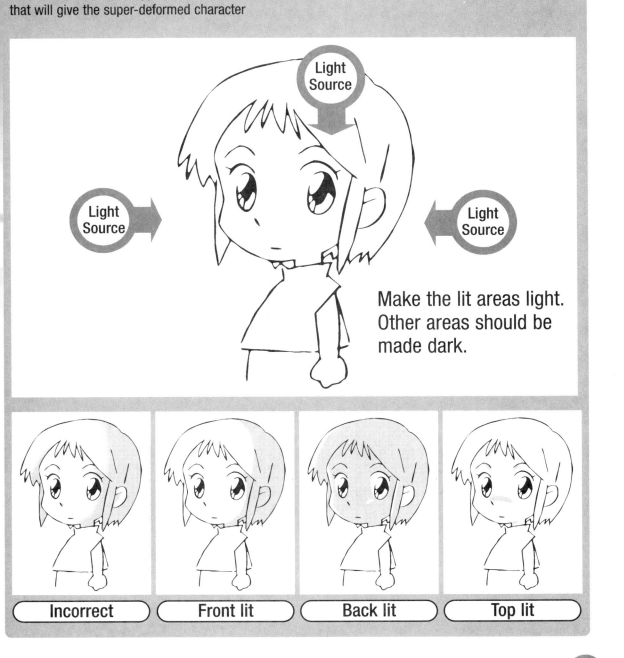

Light Source

Light Source

Light Source

Make the lit areas light. Other areas should be made dark.

Incorrect | Front lit | Back lit | Top lit

Maintaining Balanced Proportions

○ ● ○

Now that you have learnt a little about the facial layout, let's take a look at figure proportions. Naturally, proportions bear a relationship with facial layout, so the proportions offered here are not absolute. Looking at the 1:3, head-to-body figures and then again at the realistically drawn figures on this page, you will likely note the arms and legs are proportioned fairly similarly to those of the realistic figures.

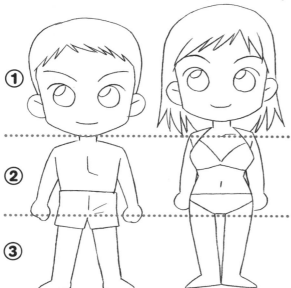

Thus, if you are able to draw a realistic figure, then, given that you comprehend those proportions, you should be able to apply these to achieve a basic proportional balance while stylizing the details. However, you will need first to consider what sort of head will match the facial layout you already designed. Failing to do so will result in a character with ugly proportions.

If you are going to create your own proportions, first design the facial layout. Then, devise a figure that suits the character's face.

(1:3 Head-to-Body) Here, the entire figure is 3 heads in height. Matching the shoulders' width to that of the face results in a satisfactorily balanced figure.

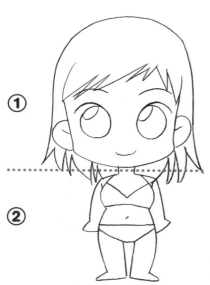

(1:2 Head-to-Body)

Here, the figure is 2 heads tall. The shoulder width should be narrower than that of the face. The head and the figure should have approximately the same area to achieve pleasing proportions overall.

Points of Note for Male/Female Figures

- Breasts
- Musculature
- Curving at the waist
- Pelvis
- Groin

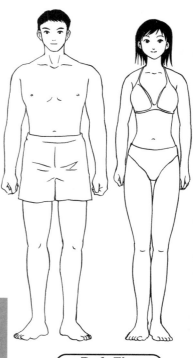

(Ref. Fig.)

Styles of Representation

Hefty Builds

Overweight Build A

When drawing a portly character, select clothing that will allow you to add highlights. Use the highlights to suggest creases between rolls of fat and flesh.

Overweight Build B

This is a common build in gag (comedy) *manga* but has been losing popularity in recent years. Dressing him in clothes that are too small and pants that cannot be closed at the waist creates an illusion of corpulence and makes a lovable character.

Overweight Build C

Here, the plumpness is to the point where flesh sags. The image can be somewhat disparaging, but it is also a way of representing obesity that the viewer quite often finds easy to understand.

Female Characters

In the case of an adult female, emphasizing roundness in the breasts, turning them slightly upward generates a convincing look. Builds A through C above may be used for girls.

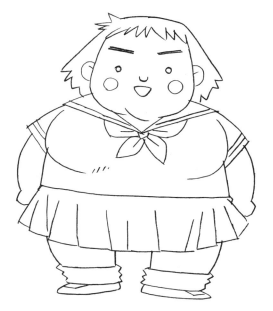

Styles of Representation

Thin Builds

Gaunt Build A

This is an extremely popular method of representation. The ribs are emphasized to generate a gaunt look.

Gaunt Build B

Here, the ribs do not show, but the slack fit of the pants or other clothing suggests a skinny build. Likewise, this is a favorite means of representation in *manga*, depending on the genre.

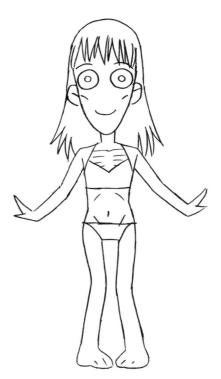

Gaunt Build C

Here, a realistic emaciated appearance is faithfully reproduced in stylized form. In *manga*, such a look is typically used in moderate form to suggest an ailing character. Take care not to overdo this look, or a morbid image will result.

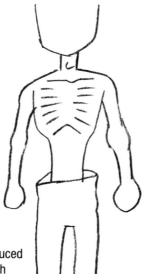

Female Characters

In the case of an adult female, emphasizing the curving at the waist underscores femininity. The pelvis should also be widened. Builds A through C above may be used for girls.

Muscular Builds

To draw a muscular build, first you will need to learn how the muscles connect. Still, avoid an overly faithful representation, or your characters will look freakish. Give moderate emphasis to the chest and stomach muscles to create a general brawny impression.

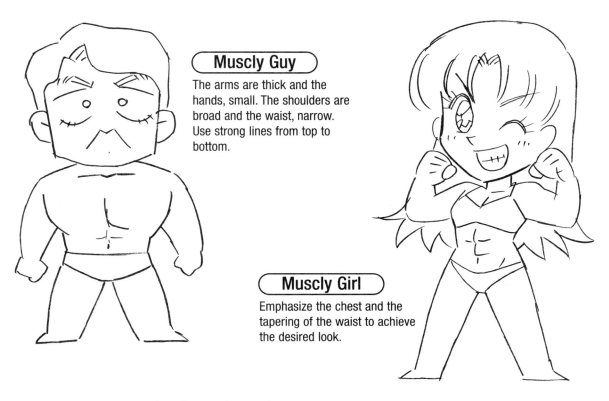

Muscly Guy

The arms are thick and the hands, small. The shoulders are broad and the waist, narrow. Use strong lines from top to bottom.

Muscly Girl

Emphasize the chest and the tapering of the waist to achieve the desired look.

Remember to Think in 3 Dimensions

uscles are not flat but 3-dimensional, so you need to think in volumes when drawing them. It is unavoidable: muscles move and have shadows, vitality, and luster.

Study bodybuilders and athletes to learn about muscle volume.

Short Lesson
Mismatching to Create Individuality
○ ○ ○

I touched on this earlier as a cautionary point, but in actuality disrupting the figure's proportional balance or assembling very different body parts may make for an interesting character.

Needless to say, this is not always the case, and if the degree, or reason for stylization is unclear, then the resulting character will just appear awkward rather than unique.

Skillfully contrived mismatching is occasionally used in character design. For example, an elderly character with alert eyes or an effeminate male instructor may strike you as inconsistent, but this incongruence makes for a fascinating, individualistic character.

Example of mismatching where some sort of ingenuity is needed—like dressing the character in youthful clothes.

Sniffle

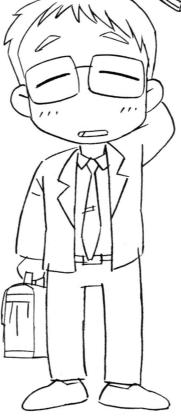

Mismatch of a child with an adult's face

Mismatch of a suited businessman with a boyish face

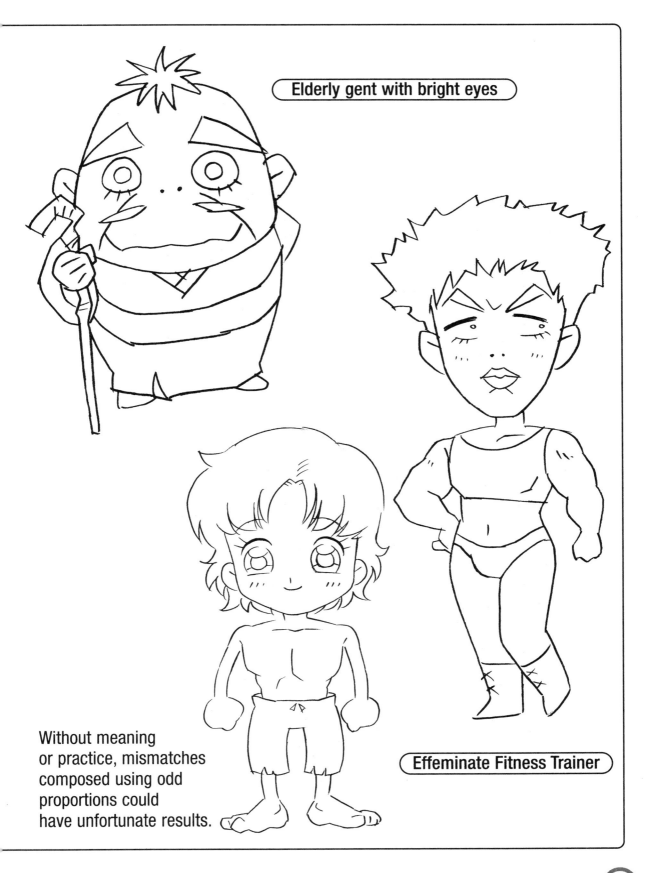

Elderly gent with bright eyes

Effeminate Fitness Trainer

Without meaning
or practice, mismatches
composed using odd
proportions could
have unfortunate results.

Proportioning Arms and Legs

How long should the arms and legs be made to achieve a well-balanced look? The answer is so that they match the body. In truth, even though children's limbs come in varying lengths, proportionally they do not differ that much from adults. Ignoring the head size and calculating the limb length based on the body's height should allow you to create a well-balanced super-deformed character.

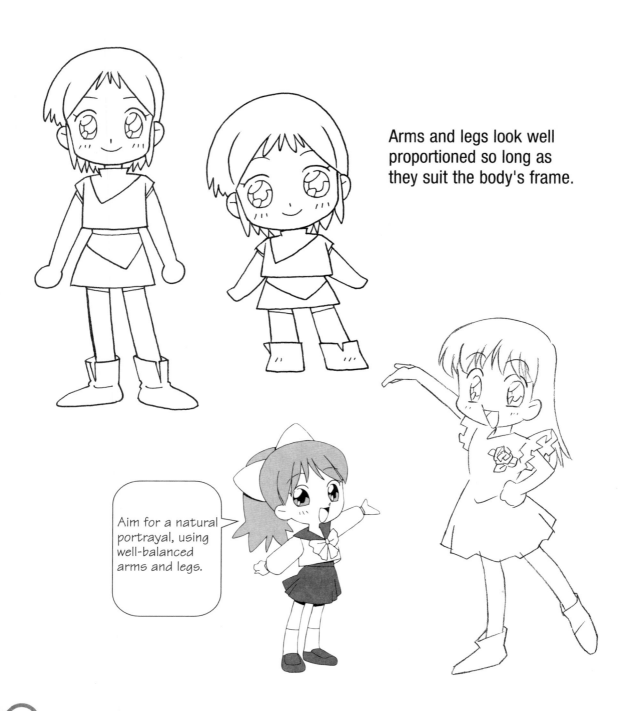

Arms and legs look well proportioned so long as they suit the body's frame.

Aim for a natural portrayal, using well-balanced arms and legs.

Disrupting Balance for Effective Comedic Portrayal

Conversely, disrupting the balance may have
fortuitous effects in the case of comedic portrayals.
Let's look at a few examples.

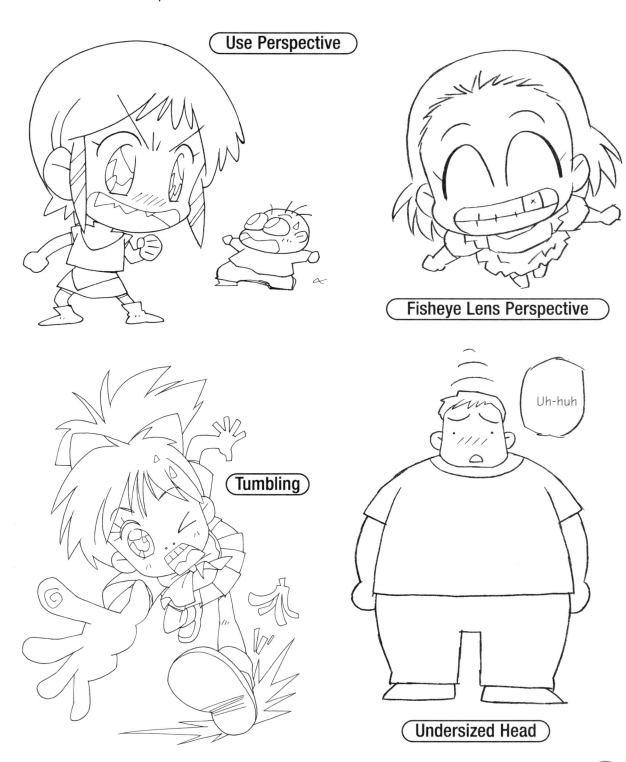

Use Perspective

Fisheye Lens Perspective

Tumbling

Uh-huh

Undersized Head

Super-deformed Character Portrayal

This topic was covered earlier in this book, so let's consider this review. Characters with head-to-body ratios of 1:3 or 1:2 are perfectly acceptable, but when the character is portrayed in engaging in an act, the joints will have to be bent. Naturally, there are actions that do not require bending. However for those occasions where straight joints appear awkward, artists use a crude technique whereby the number of heads-to-body-length is increased.

As a cautionary note, when altering the head-to-body ratio, keep the change to a minimum, and avoid extreme changes in the degree of stylization.

Bend Joints, Modifying the Head-to-Body Ratio as Needed

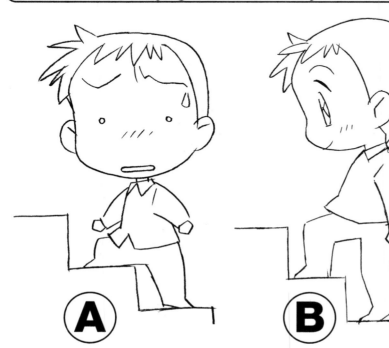

Skillfully adjust the head-to-body ratio according to the situation, such as exemplified in A and B. *Manga* is a created product, and super-deformed characters do whatever their creators want (grin).

Chapter 3

○ ○ ○ ○ ○ ○

Super-deformed Anything and Everything

Character Design On-Location

I would like to discuss here stylized characters I designed some time ago. A game manufacturer had contracted me to create a character. The figures that you find on these two pages are all this character (chuckle). First of all, in order to create a presentation to determine how the stylized character should look, the artist has to play around with various looks for the same lead character. There is the young lad type, the hero type, the dunderhead type, and many more. Then all of the prototype characters created are pared down, and only one is selected as the lead.

In this case, the boy with the staff on the following page was the one selected. Next, I thought about how this stylized character would look in a sub-screen in a more realistic rendition and developed the more realistic version based on the stylized original.

If the artist creates a realistic character from a stylized one, an entirely different set of techniques is used than those described herein.

In such cases, I recommend think about what features to abbreviate and how to create a super-deformed character while you imagine how the super-deformed character would look if he or she had a regular *manga* character head-to-body ratio. This will facilitate the reverse process.

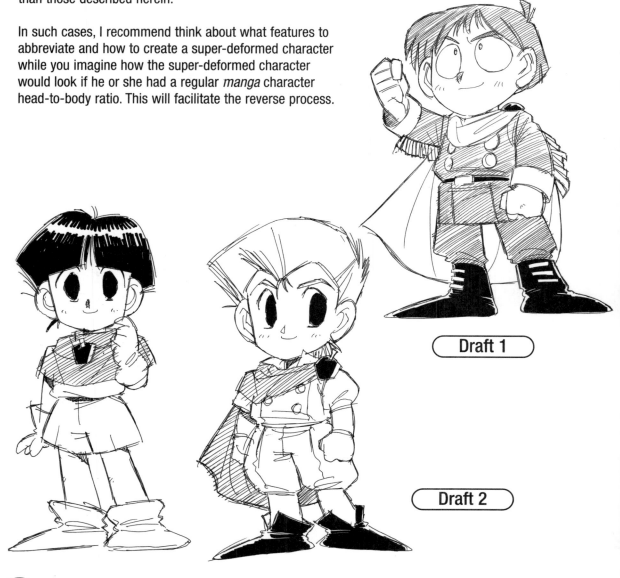

Draft 1

Draft 2

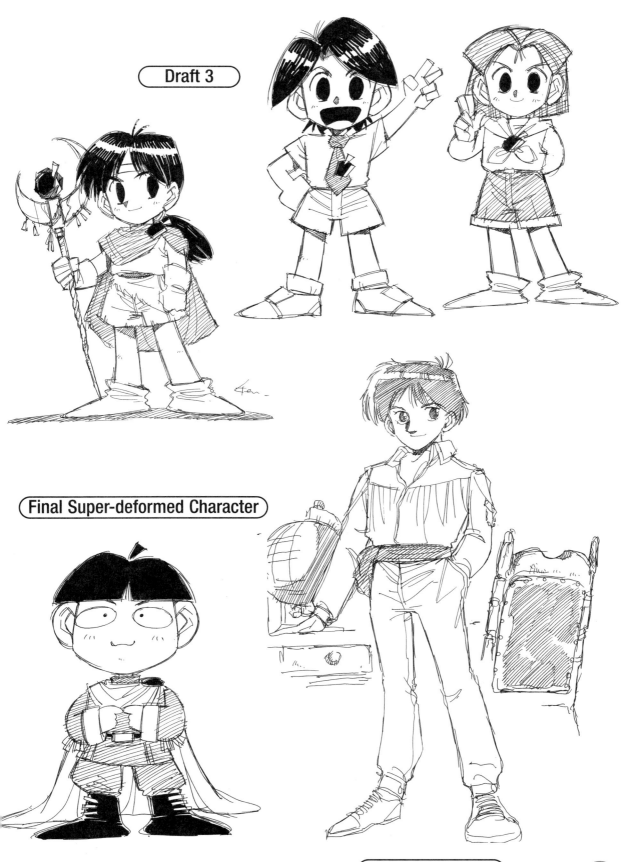

Draft 3

Final Super-deformed Character

Realistic Version

In the case of this heroine, I selected the girl holding the staff to be the super-deformed character for the realistic version, but the character actually used ended up being the girl in the shorts on the following page. Thus, there are various paths that can be taken before the final character is determined (wry laugh).

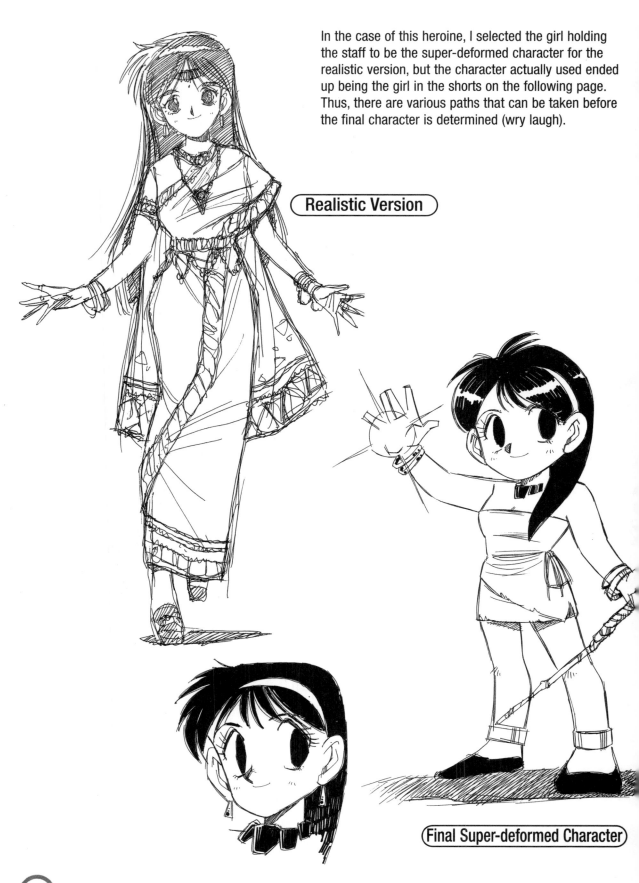

Realistic Version

Final Super-deformed Character

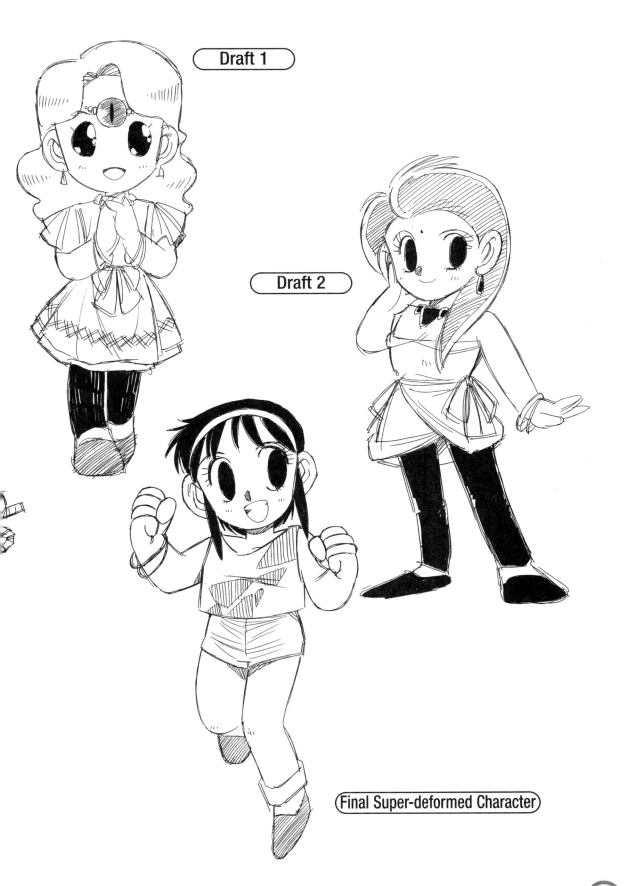

Draft 1

Draft 2

Final Super-deformed Character

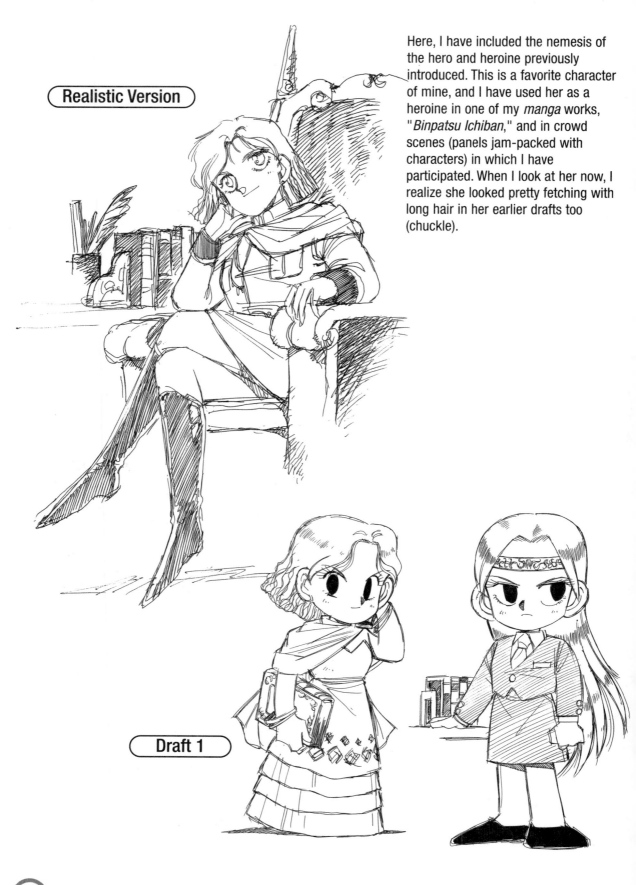

Realistic Version

Draft 1

Here, I have included the nemesis of the hero and heroine previously introduced. This is a favorite character of mine, and I have used her as a heroine in one of my *manga* works, "*Binpatsu Ichiban*," and in crowd scenes (panels jam-packed with characters) in which I have participated. When I look at her now, I realize she looked pretty fetching with long hair in her earlier drafts too (chuckle).

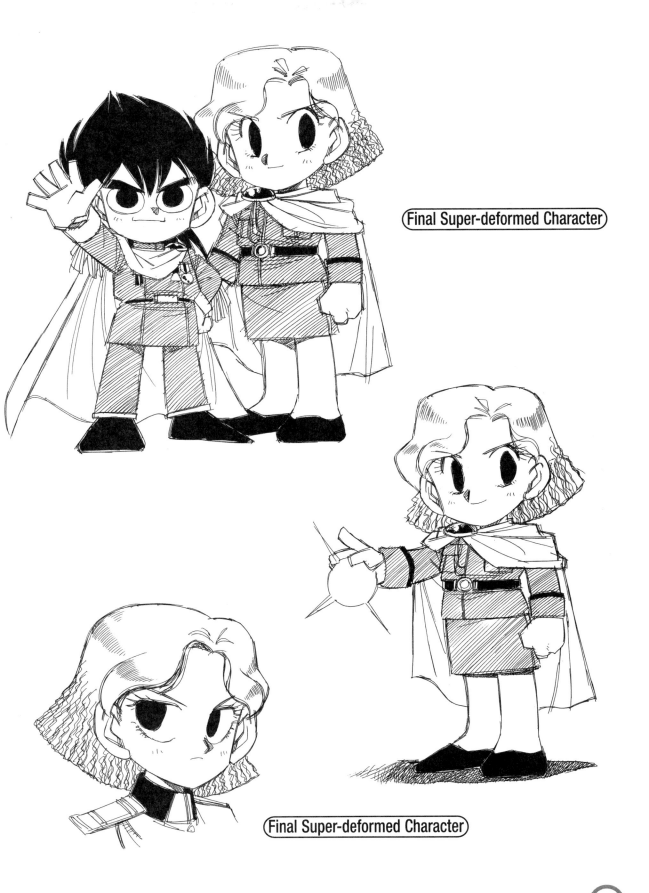

Final Super-deformed Character

Final Super-deformed Character

This is the hero's young male sidekick. At the planning stage, he was to be a bandit, so I tried to retain a bit of that flavor in this image.

It is terrific to give characters idiosyncratic skills like this. However, the hero or heroine could then seem bland in comparison. The creator certainly does face a number of difficult issues.

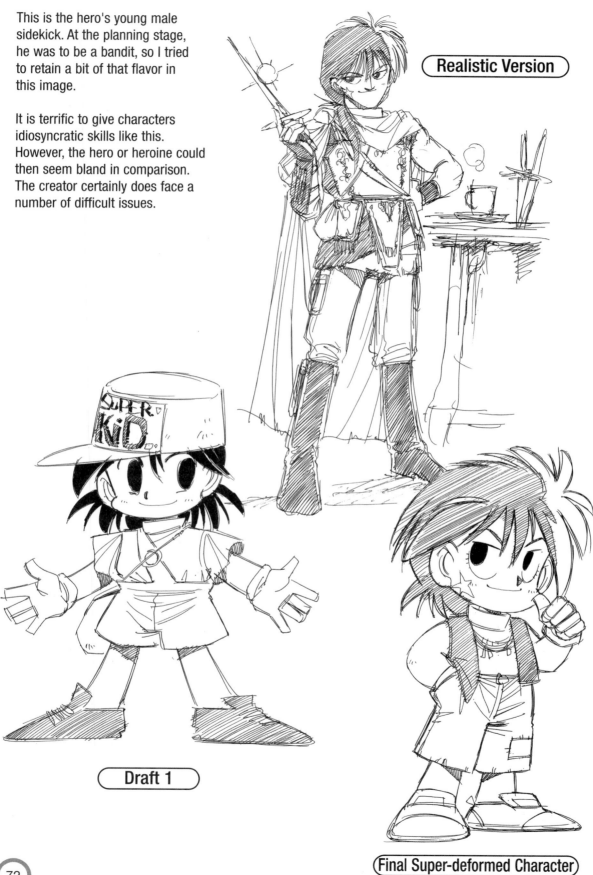

Realistic Version

Draft 1

Final Super-deformed Character

The Hero's Parents

The Enemy Commandant

Super-deformed Characters and Stylizing Clothes

Up to now, we have been focusing on super-deformed character faces and figures. However, it has probably occurred to you that there is an accessory that characters absolutely need—clothing. Obviously, since super-deformed characters are wearing this clothing, it should not be realistically drawn. For that reason, the clothing must be stylized to match the super-deformed character. Use similar means as you do for the face and figure to draw out distinguishing features in the clothing. A slight difference in pen stroke could affect the flavor of the article. The mood projected by the wearer affects the clothing article as well. Likewise, sensibilities of the artist could make the character look tacky or neat and tidy. (I guess this is all moot for naked characters).

Clean and Fresh

Tacky and Grimy

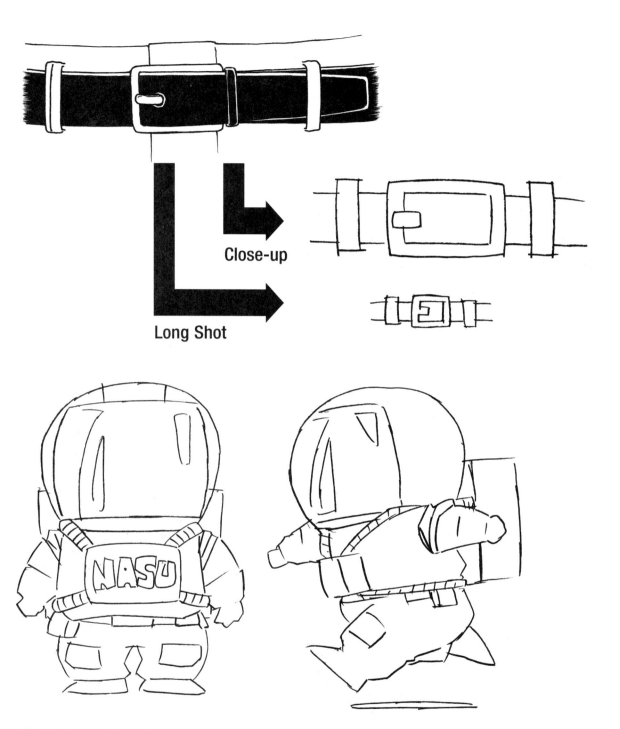

Close-up

Long Shot

Clothing is used less substantially than the face as a means of distinguishing a character's individuality. As a result, clothing stylization can be pushed to the limits in long shots and still be recognizable. Please refer to the belt example above.

Somewhat of an exception to this rule would be clothing where we do not see the character's face, such as spacesuits or firefighter uniforms. In these cases, the distinguishing features themselves project the character's personality. Consequently, pushing stylization to the limits, as mentioned earlier must be held in check, while the clothing is executed so as to project individuality.

Points of Caution in Drawing *Kimono*

Traditional Japanese clothing requires particular attention when drawing. Recently, young Japanese have fewer opportunities to wear *kimono*, and some have never even worn traditional Japanese dress. Of course, personal interests may be at play here, which is perfectly fine. However, if you, as the artist, ever find yourself having to draw *kimono*, you will be in need of accurate knowledge. On these next pages I discuss common mistakes in drawing *kimono*.

The most important factor concerning *kimono* is "construction." To explain this briefly, so even someone not interested in detailed *kimono* facts will understand, an undergarment structured identically to a *kimono* is worn underneath the *kimono* proper. Conceive of this as a *kimono* being worn over a *kimono*. The artist needs to be aware of this fact and include overlapping collars when drawing *kimono*.

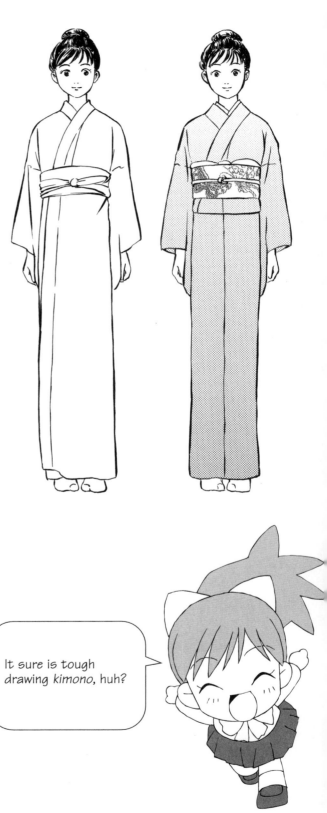

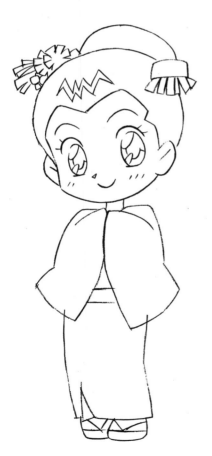

It sure is tough drawing *kimono*, huh?

The Collar

Below, you see 3 figures of *kimono* collars. The top figure is the most realistic representation. A moderate stylization of that resulted in the next figure. At this stage, the inner collar is still visible, which is the correct representation. There may be rare occasions when the outer collar should perfectly overlap and obscure the inner collar. Since this only results when two outer *kimono* are worn, normally hiding the inner collar is nothing more than a gross error.

The figure underneath is a more extreme stylization. Because the under *kimono* is typically white, the line denoting where one half folds under the other may be omitted in consideration of lighting. However, the same line for the outer *kimono* should be retained.

An even more stylized collar would be that worn on the girl. Both the fold line of the inner and outer collars may be omitted, as seen on the girl. However, leaving a nominal fold line of just a few millimeters will make the *kimono* infinitely more visually comprehensible.

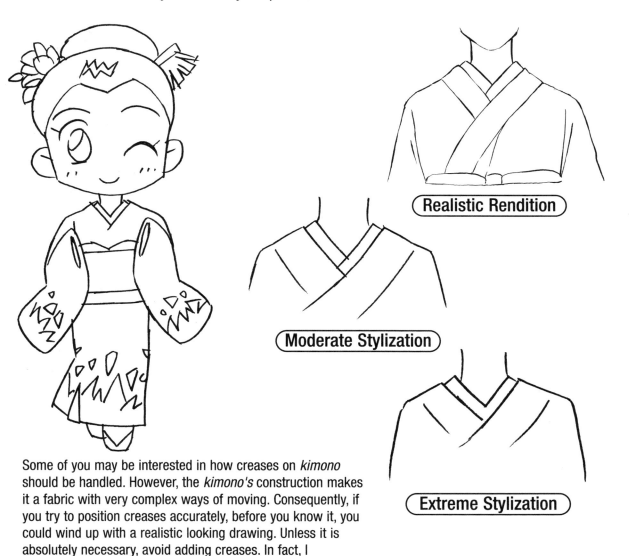

Realistic Rendition

Moderate Stylization

Extreme Stylization

Some of you may be interested in how creases on *kimono* should be handled. However, the *kimono's* construction makes it a fabric with very complex ways of moving. Consequently, if you try to position creases accurately, before you know it, you could wind up with a realistic looking drawing. Unless it is absolutely necessary, avoid adding creases. In fact, I recommend that you render the fabric's texture as an object with volume without using creases.

Stylizing Clothing

Pictured on these pages is a variety of clothing. Please note that while attire is important, it needs to retain some relationship with the character, and overall visual balance must be maintained. If not, then your carefully designed clothing will be for naught. Refer to cautionary points and discussion of mismatching when designing your characters' exciting outfits.

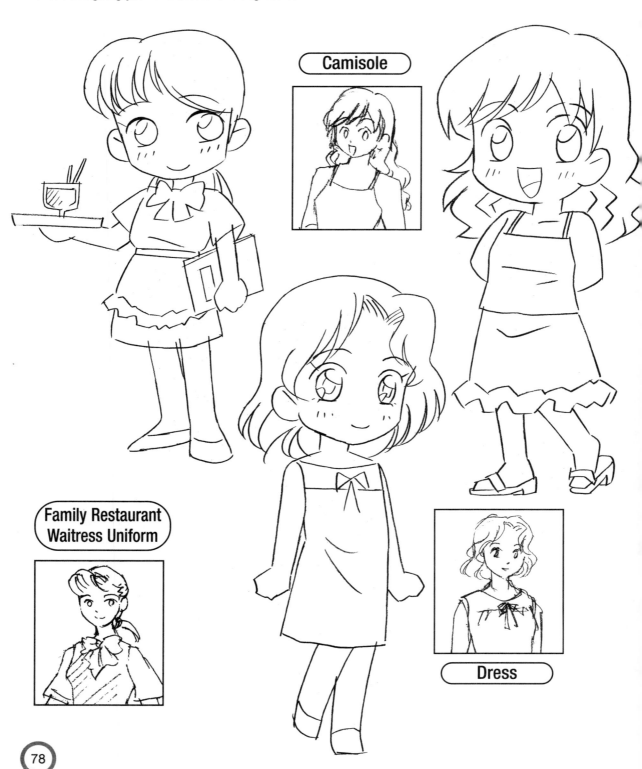

Camisole

Family Restaurant
Waitress Uniform

Dress

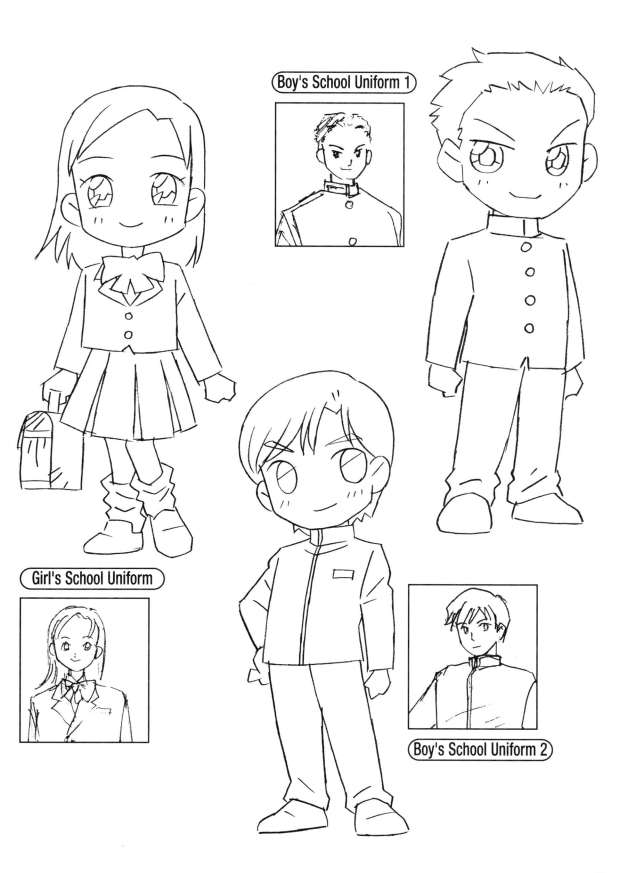

Boy's School Uniform 1

Girl's School Uniform

Boy's School Uniform 2

Super-deformed Characters and Backgrounds

All righty then, we discussed clothing, and we discussed the face and the figure, so you may think that this book on human figures should be coming to a close. However, truth be told, we still have more ground to cover. Your lovingly designed characters still need a space in which to dwell.

So, let's take these next few pages to discuss backgrounds.

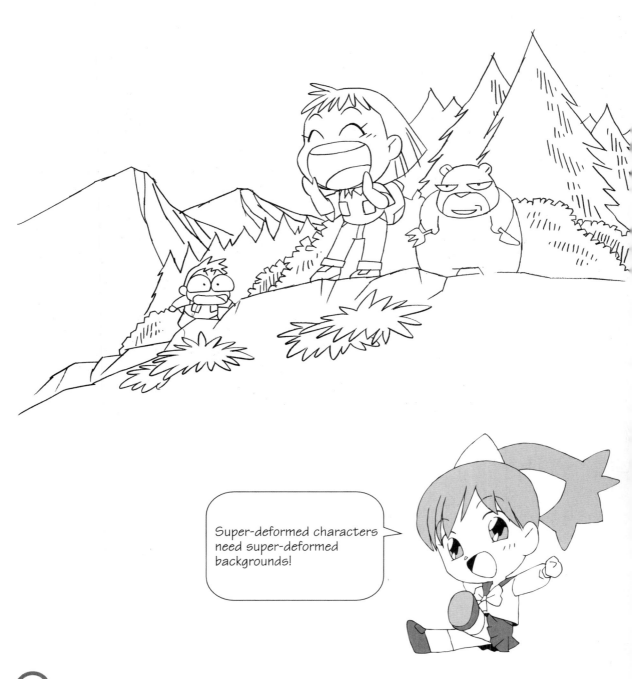

Super-deformed characters need super-deformed backgrounds!

Commercial Building

Buildings inevitably appear somewhere in a background, and like people, buildings always have distinguishing features. Let's look at emphasizing these features.

Often, simply adding some form of signage will indicate that a typical building is for commercial use. Including hanging ad posters or ad balloons on a multilevel building creates the illusion of a department store or supermarket. Prominently place a clock on a symmetrical building and scatter shrubbery here and there to create a school. Add balconies to exterior windows, outdoor mechanical units and a water tank to the roof to create an apartment building. If you have successfully identified the distinguishing features of a wood-structure apartment house, you should be able to use them even when modifying the degree of stylization.

School

Department Store

Apartment Building

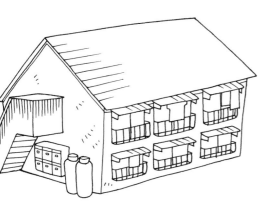

Wood-Structure Apartment House

While you do not need to draw the fine details, the number of roughly drawn details should match the original. Perspective may also be disregarded to a certain extent.

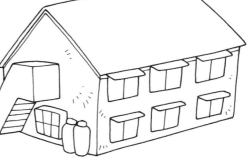

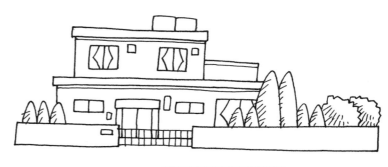

(**Affluent Home**)

A flat roof, the number of shrubs, spaciousness of the yard, and curtains in the windows help suggest an affluent house. Modifying the roof's shape, the house's width, and the placement of trees in the yard results in an average home.

(**Average Home with a Yard**)

Stylizing Cityscapes

While I did write "cityscape," distant views of buildings rendered as skylines perhaps appear better as super-deformed character backdrops. Please note, however, that building outline heights must be drawn randomly. Otherwise, your skyline will look like a bunch of oscilloscope pulses, which will cause your scene to lose its sense of a living space and reality. Perhaps beginners might be better off looking at an actual photograph when drawing the undulations in the cityscape.

Another special stylization effect is reverse perspective. This technique consists of making the bottom of the building smaller rather than the top, which would be normal practice. This gives the buildings an eccentric flavor. Use this technique strategically, however. Overuse could cause the look to lose its idiosyncratic nature.

Assorted Backgrounds and Props

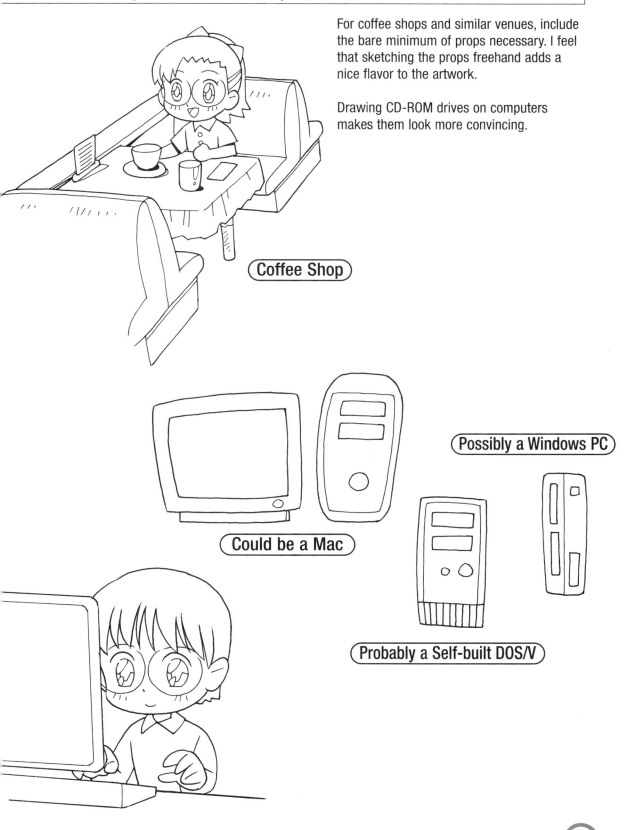

For coffee shops and similar venues, include the bare minimum of props necessary. I feel that sketching the props freehand adds a nice flavor to the artwork.

Drawing CD-ROM drives on computers makes them look more convincing.

Coffee Shop

Possibly a Windows PC

Could be a Mac

Probably a Self-built DOS/V

Nature can also be exaggerated according to the situation or intended use. However, take care. While how the sun touches a mountain, etc. helps express volume and time, adding too much hatching and pen strokes could muddle the direction of light, causing your artwork to appear flat.

The preferred method for suggesting wind is to show a character's hair or clothing fluttering. However, in those cases where this is not an option, simple lines may also be used.

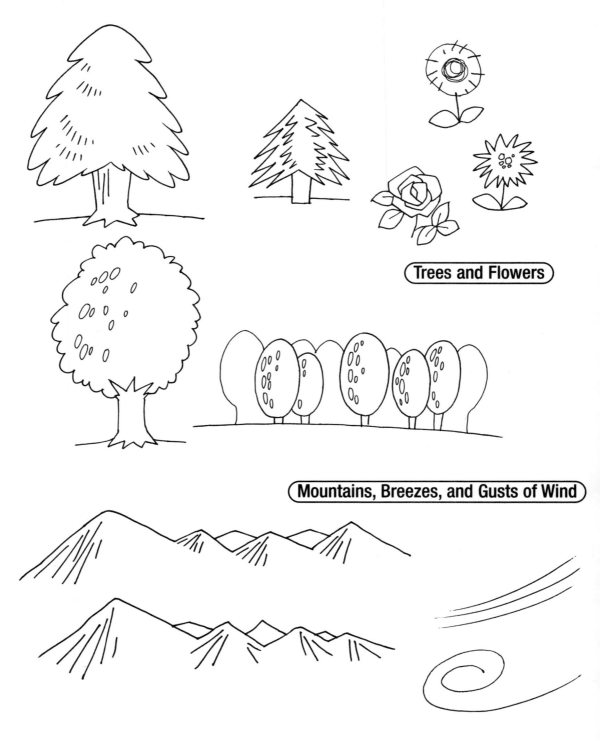

Trees and Flowers

Mountains, Breezes, and Gusts of Wind

Lightning

Skeleton

Water and Water Drops

Cars

Guns

In-Depth Look
Super-deformed Robots
○○○

I have participated in a number of projects involved in turning robots into super-deformed characters. These projects have been so successful that today stylized characters basically constitute my bread and butter. Some readers may be interested in delving deeper into stylized robot characters. However, what I am offering here is just a brief bonus discussion that you can easily use as reference. I have included a few samples of my students' work.

Many inexperienced artists taking their first stab at drawing a stylized robot character may find the task extremely difficult and bothersome, given the robots' vast array of parts. However, if you are familiar with the techniques I discussed, then you should have absolutely no problem creating a super-deformed robot. The reason is that if the robot is in fact an android, then you can conceive of it as a human in somewhat stiff clothing and use the same methods to create a regular super-deformed character.

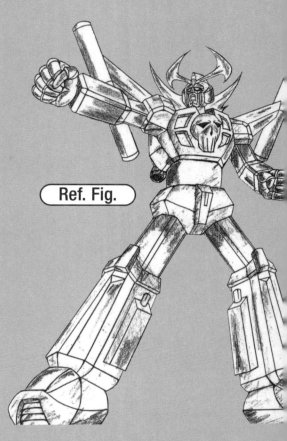

Ref. Fig.

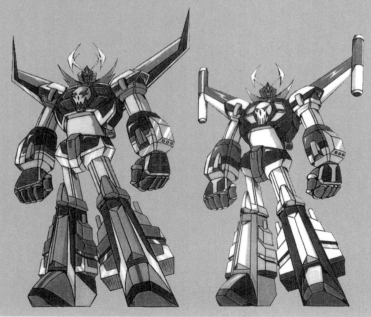

Plan Overview

This was a phenomenal, gung-ho robot anime incorporating the essence of 1970s robot anime imbued with its creator's zeal. The concept was to use a spirited, energetic anime to destroy the public's image that "robot anime" meant "animation of robots battling one another."

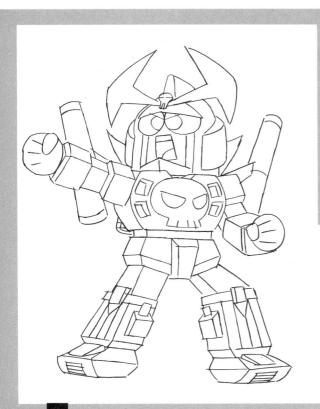

Hyper-stylization Stage 1

Look at the realistic drawing of the robot on the previous page and think about which joints relate to a person's joints, and retain those joints necessary. Next, gradually look for distinguishing features and eliminate any unnecessary parts.

Completed Super-deformed Character

Finally, adjust the figure's overall balance. You get the feeling looking at the little guy that he could get even smaller and still retain his personality (chuckle). I hope I'll get to show you more characters in the future.

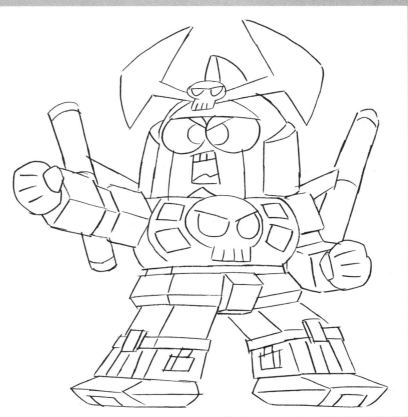

In-Depth Look
Transforming Serious, Fiery Characters into Super-deformed Characters

○○○

These are the "heavies" (chuckle) that appear in the robot anime discussed previously. Let's try using these to make super-deformed characters.

In the case of a heavy, since their idiosyncrasies are already out for all to see, trying to draw them out even further would either dilute the character or make the character's personality abnormally lopsided. Well then, what areas actually require attention? Heavies may hold some sort of bitterness with respect to the viewer, and consequently often project an intense impression. When you do try to capture these idiosyncrasies, you should play down any unpleasantness, while emphasizing those qualities that give the impression of a strong personality. In order to achieve this, I recommend more than anything else following the stages of the stylization process.

For this In-Depth Look, I have included rough sketches that I produced during the stylization process. Please look at these samples to get a sense of how the process works.

Reduce female characters to the simplest form possible. If she is going to appear individually, giving her a gigantic head as described previously is one way to make her more endearing. Naturally, when she is placed amongst other characters, the degree of her stylization should be adjusted to match that of the other characters.

Completed Image

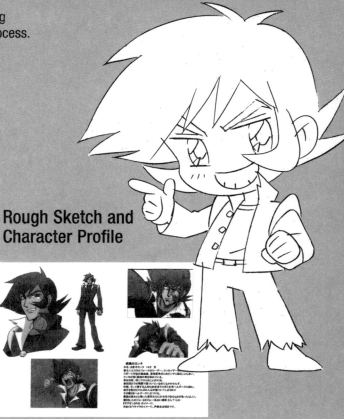

Rough Sketch and Character Profile

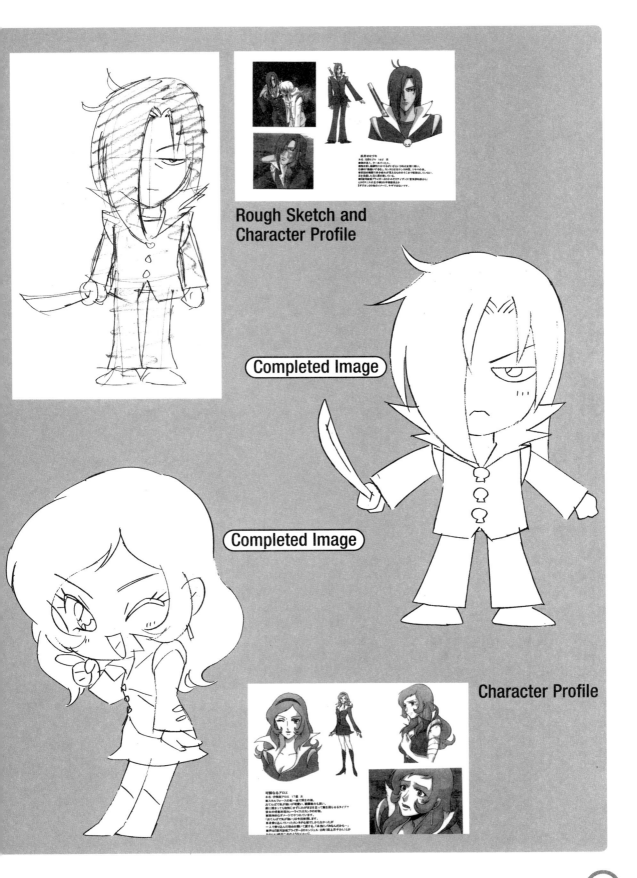

Rough Sketch and
Character Profile

Completed Image

Completed Image

Character Profile

In-Depth Look
Super-deformed Characters and Hand Stylization

The human hand is a body part with an extremely complicated structure. The hand contains numerous joints and is capable of intricate movement. Consequently, one expects to encounter many complications in exaggerating or omitting traits. However, I have one interesting tidbit of advice to offer, and that is there is nothing wrong with lying. Take a look at the *manga* or comics you're reading. Are all of the hands bending and moving in a totally natural manner? I am willing to bet that some of the joints just do not bend the way pictured and that some of the motions are physically impossible. The reason they appear plausible is because we hold assumptions regarding what a hand should look like.

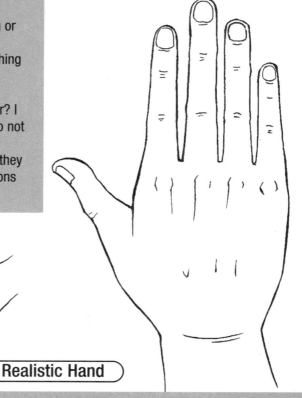

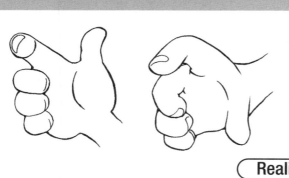

Realistic Hand

Rock/Scissors/Paper

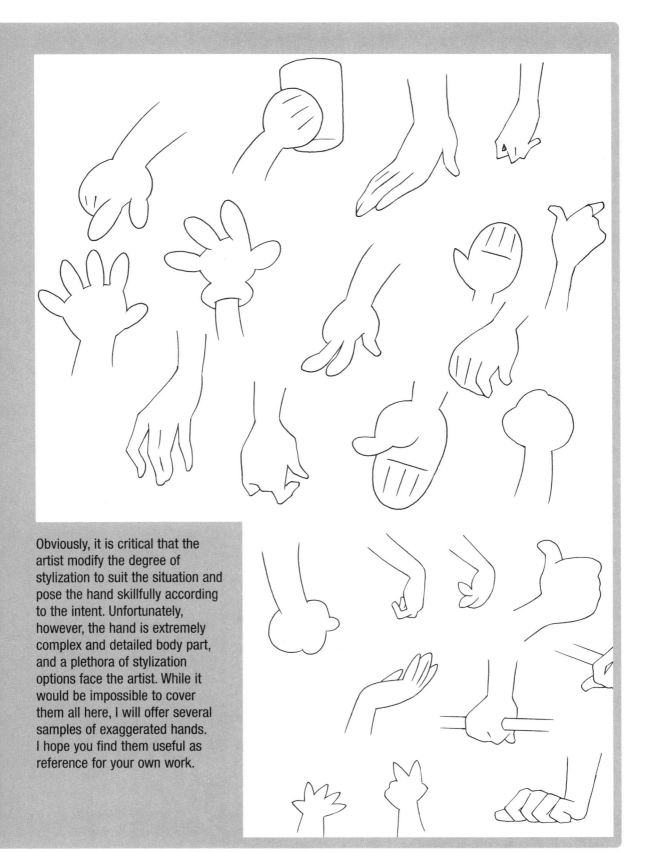

Obviously, it is critical that the artist modify the degree of stylization to suit the situation and pose the hand skillfully according to the intent. Unfortunately, however, the hand is extremely complex and detailed body part, and a plethora of stylization options face the artist. While it would be impossible to cover them all here, I will offer several samples of exaggerated hands. I hope you find them useful as reference for your own work.

Posing Super-deformed Characters

On the next few pages are stylized characters of assorted occupations and in various dress to be used as reference.

Many feel that in recent years *manga* characters have been becoming less distinctive. In the past, characters were so clearly expressed that one could glean what type or role he or she played in a single glance. The schoolyard gang leader, probably soon to be designated an endangered species, is one such character. And then there is the pampered rich kid somewhere in his entourage. Fujiko Fujio's method of drawing out a character's individuality to the max, which is considered proper practice, is still continued in *manga* circles today. Fujiko's characters are so terrific that even those picking up his work for the first time are able to understand the characters' roles. I mentioned this earlier, but this is what defines a character's distinctiveness. Characters that the reader visually cannot discern who they are and what they are doing will not last years down the road. So, what prevents you from trying to create your own character just saturated in individuality right now?

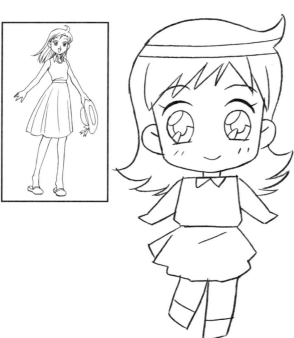

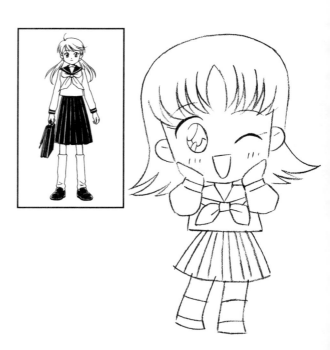

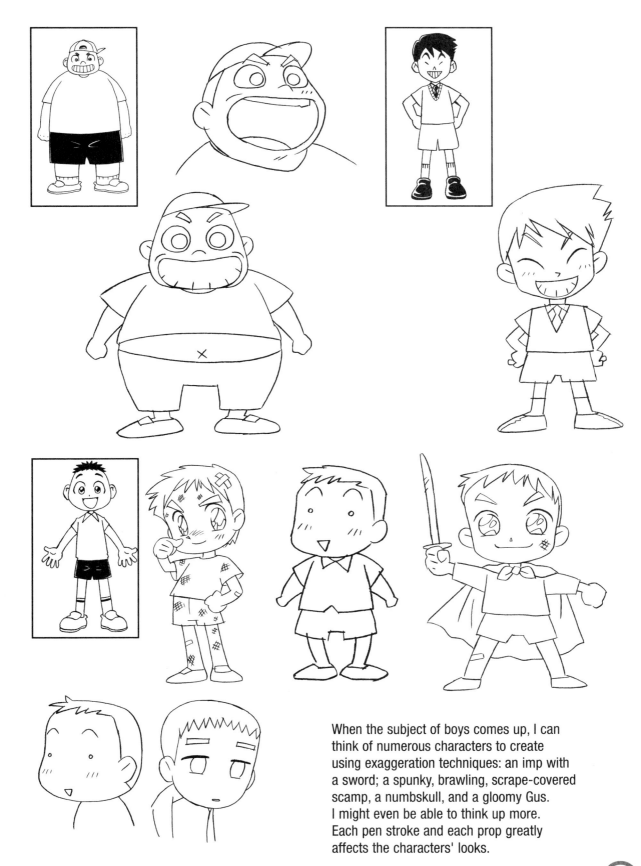

When the subject of boys comes up, I can think of numerous characters to create using exaggeration techniques: an imp with a sword; a spunky, brawling, scrape-covered scamp, a numbskull, and a gloomy Gus. I might even be able to think up more. Each pen stroke and each prop greatly affects the characters' looks.

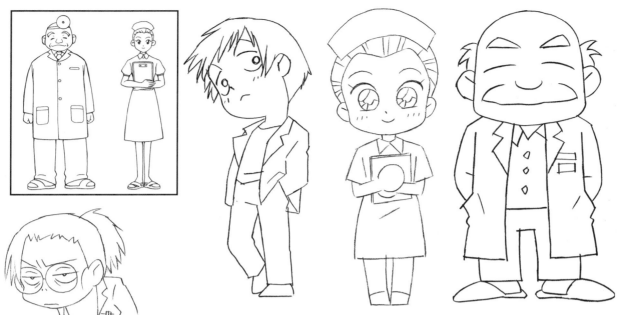

Doctors come in various forms. There are kindly doctors and quacks. For the latter, draw the doctor hunched over, to suggest a sense of danger like that one might find in a darkened alley. However, take care when drawing the character hunched over that the figure rounds only at the shoulders and not the small of the back. (Otherwise, you will unfortunately end up with an elderly character. A definitively different style of bad posture is needed from that when created elderly characters.)

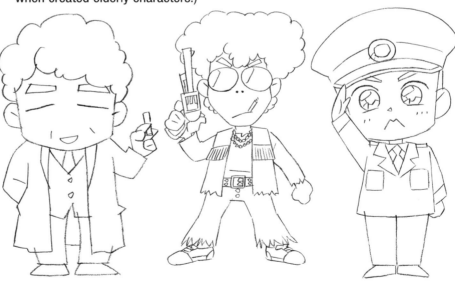

As when drawing a boy, exploiting minor distinguishing features can suggest personality differences within a given profession. For example, even amongst police officers and detectives, there is a wide assortment of possibilities: a respectful and polite rookie cop; a sunglass-sporting hot-blooded detective; or a shrewd detective, like Columbo.

Alternatively, for police officers, it might be interesting to show a disparity between the officer at work and in private, as is shown in the illustration.

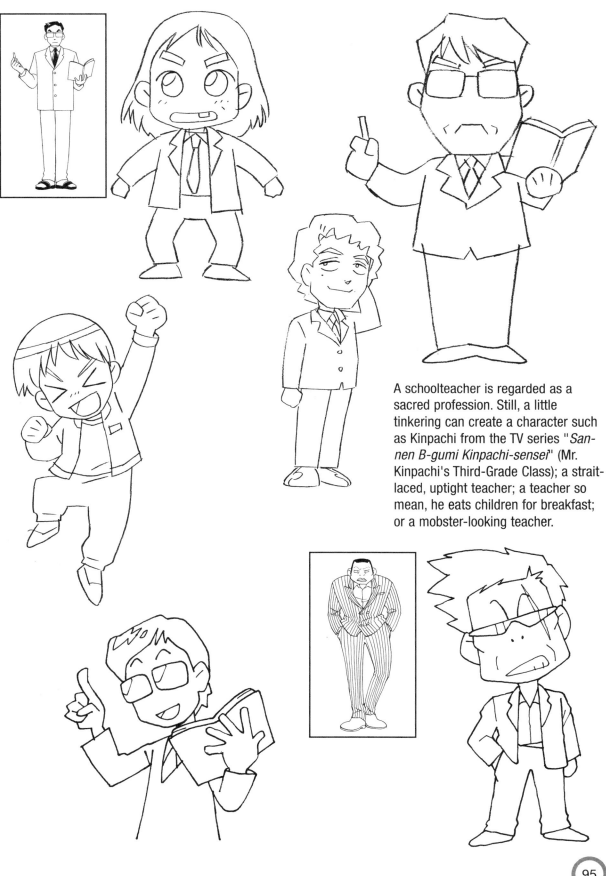

A schoolteacher is regarded as a sacred profession. Still, a little tinkering can create a character such as Kinpachi from the TV series "*Sannen B-gumi Kinpachi-sensei*" (Mr. Kinpachi's Third-Grade Class); a strait-laced, uptight teacher; a teacher so mean, he eats children for breakfast; or a mobster-looking teacher.

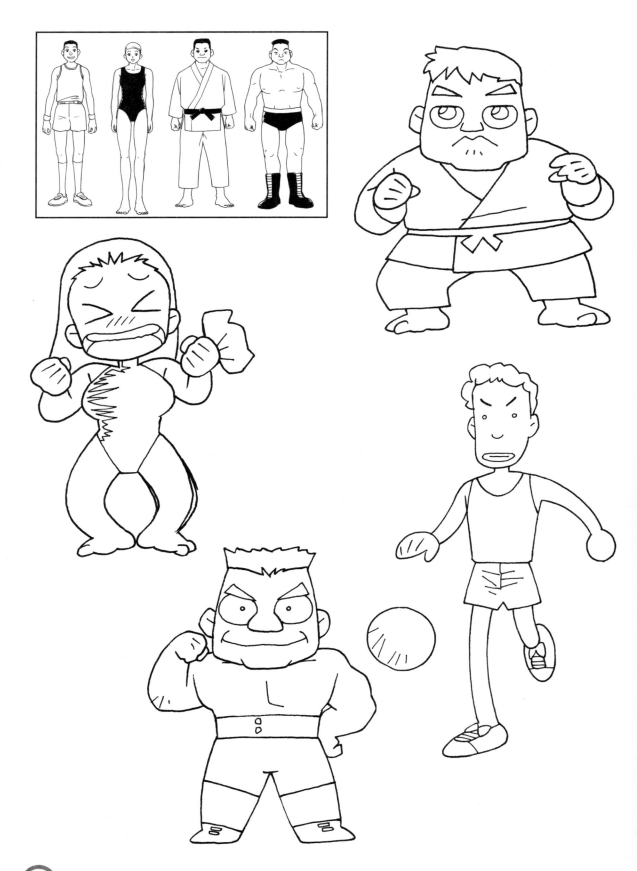

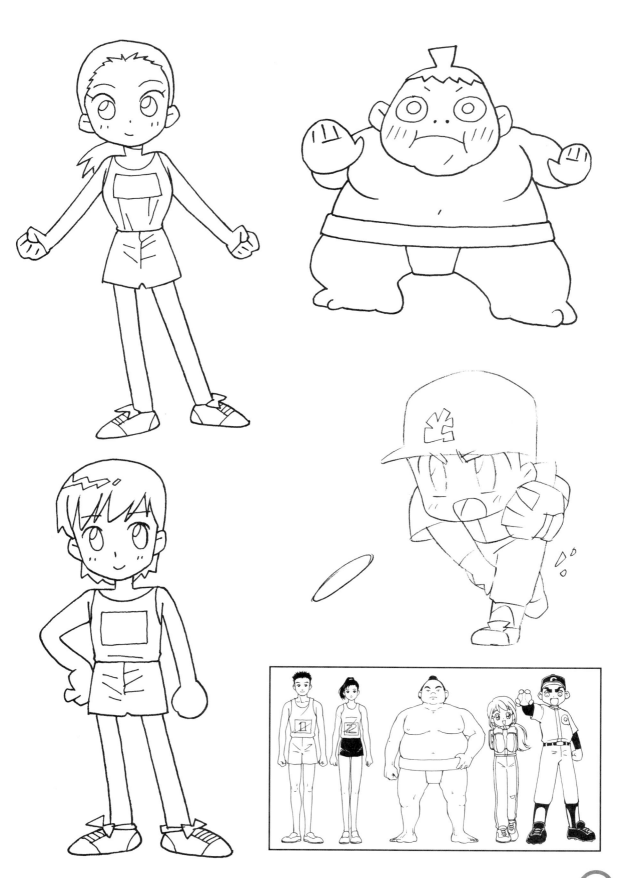

Methods of Stylization in Game Characters

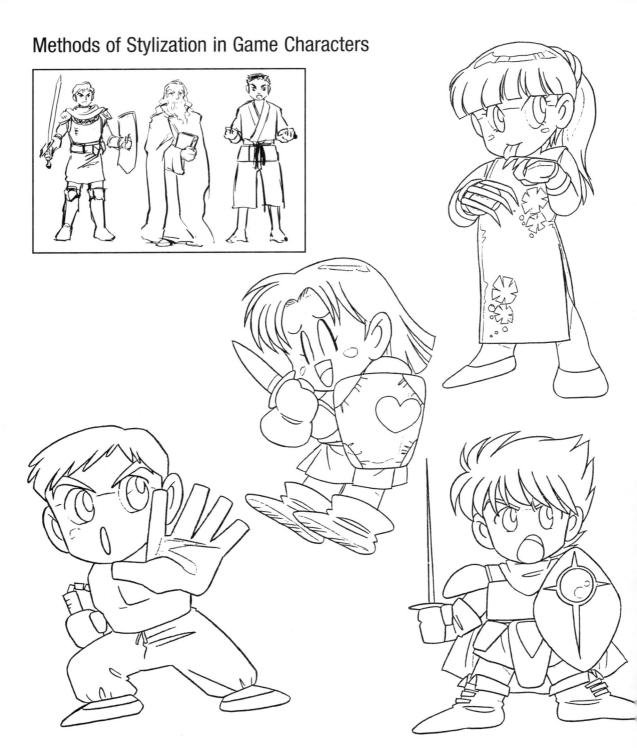

What you see pictured here are simulation game characters I created approximately 10 years ago. At the time, stylization techniques where still being developed, which is probably apparent in these images, but I still hope that you find them useful as reference.

In the case of SLGs (Simulation Games), the characters usually appear in panels, so unlike the characters in "*Dokapon Gaiden*," these characters were not intended to move, and it was important to emphasize design as a still picture. As a result, you may find that some of the characters probably couldn't move if they tried.

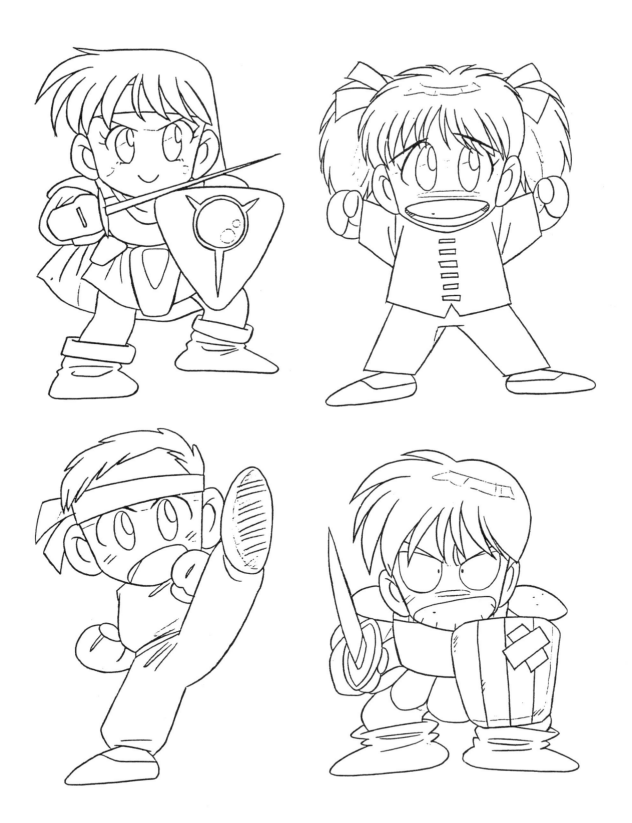

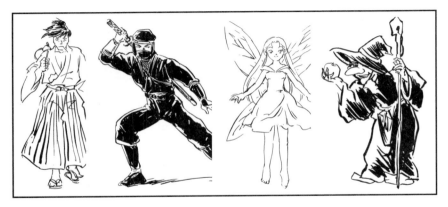

These too are characters I created about 10 years ago, so stylistically they look a bit different from what we have today. When I designed them, I had given due consideration to their roles to make them distinctive. Again, I hope you find them useful as reference.

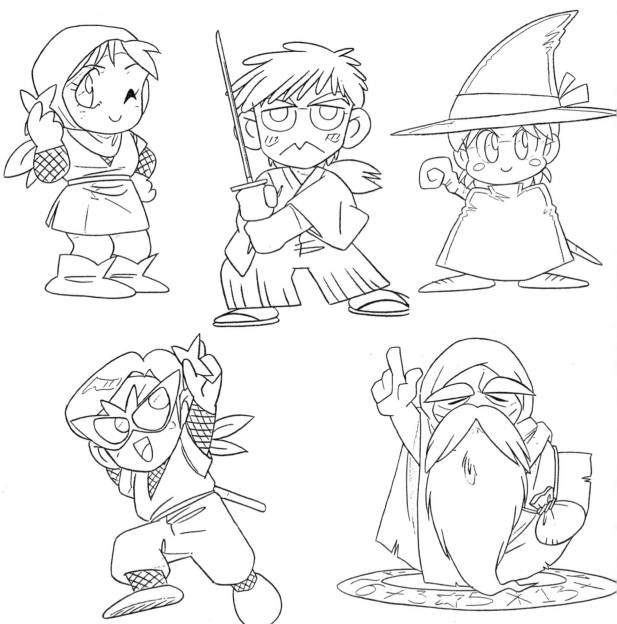

I must apologize for putting these characters in the reverse order. On this page appear characters I created using recent stylization techniques. You will probably notice the different degree of stylization and handling of pen work in these characters as opposed to those on the previous 3 pages. Monsters are a type of heavy (chuckle), so it is acceptable to handle their stylization the same as you would a human heavy. Please note, however, that how you execute them will affect whether you make them scary or lovable.

The Frankenstein Monster, Creature of the Black Lagoon, werewolf, etc. are drawn with the same eye level as a human. For heightened drama, the heads may be enlarged to boost the sense of tension or fear. Conversely, using a perspective whereby the head is made smaller does create a psychological state of fear in that the monster appears to be looking down at the viewer. However, take care: a super-deformed character's personality is concentrated in the face, so making the head smaller could backfire on you.

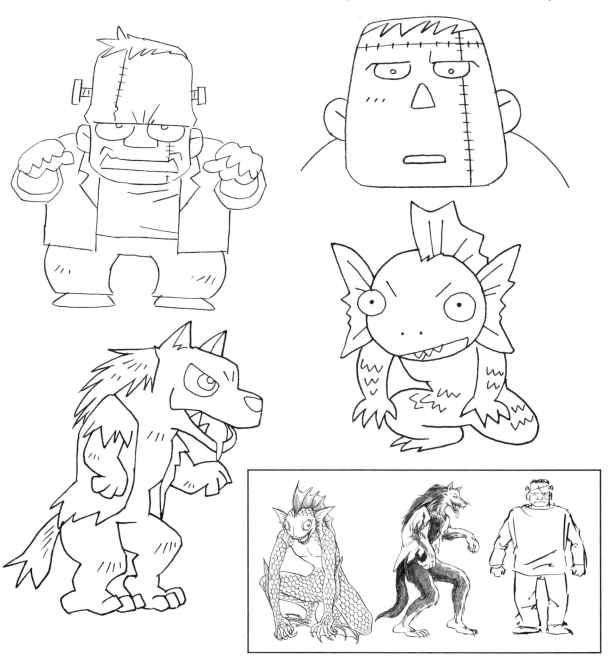

Super-deformed Character Gallery

○ ● ○

Super-deformed Character Designs for Children's Television Programs

On these pages are characters I created for an old children's television program. Sadly, they were never used (wry laugh).

I am not sure how appropriate the phrase "children's program" is. However, these characters required an unusual execution, whereby the figure was to appear flat and yet rendered as if seen in 3-D. To explain this in simpler terms, the characters were to appear as flat, two-dimensional objects. Color was also handled in such a manner as not to create a solid feel but rather to make the various parts distinguishable. There are *shoujo manga* artists who create flattish characters but use brushstrokes and gradation tone (a method of adding "color") miraculously to create a sense of volume. However, to a yet unsophisticated, young child such characters look fake. To young children, who take these images at face value, a flat character should be flat, and forcing 3-dimensionality on such a character is nothing less than offensive.

There may even be adults who look at *shoujo manga* and react with similar distaste. Thus, the character must first be regarded as a flat plane. Then, the character must be regarded as a 3-dimensional object that is able to move, in order to make a child's fantasy world come alive, where the child can play with the character. Consequently, an innocent child would sense a clash if one were to use heavy-handedly the methods of head-to-body ratio adjustment discussed previously. Hence, this was another point that needed attention. Stylization intended for children's consumption is extremely complicated requiring subtle balance and involving issues unthinkable for normal stylized characters. Even more, execution of these characters requires awareness of using clean, carefully placed lines thickly drawn to a certain extent, rather than thin detailed strokes, and it is not an exaggeration to say that stylized children's characters are absolutely the final goal of this book.

Please note that our discussion of character execution as it appears in this book is still incomplete, and I hope to cover more in later volumes.

Super-deformed Character Design for Gaming 1

These are from the unreleased character profiles I designed for the game "*Dokapon Gaiden*" some while ago.

Unlike the characters designed for the SLG discussed earlier, these characters are stylized under the assumption that they would have to be capable of motion, since Dokapon required a certain degree of movement. Thus, I needed to achieve balance in the degree of stylization and to execute the joints believably.

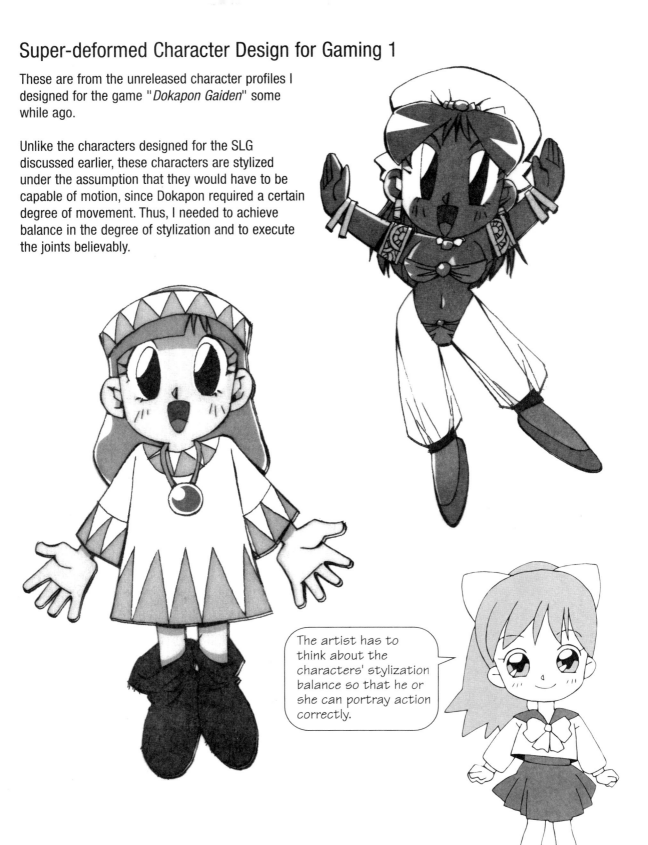

The artist has to think about the characters' stylization balance so that he or she can portray action correctly.

Super-deformed Character Design for Gaming 2

On these pages appear some of the characters I created for the game discussed on p. 98. They have been stylized to illustrate their professions and other qualities, but they have not been executed to allow motion, as movement is not a prerequisite of SLGs.

These characters represent various occupations and uniqueness. Their "eccentricities" are strongly projected. Conversely, the 2 protagonists appearing at the bottom of p. 111 do not exhibit strong portrayal of eccentricity, but rather their uniqueness is downplayed. The reason for this is if the frequently appearing protagonist was a strongly eccentric character and the player became accustomed to this, then that would cause the other highly idiosyncratic characters to lose their distinctiveness.

Metaphorically, the protagonist is like the white rice of a meal, while the opponent characters are like the side dishes. An opponent character, like a side dish, is more interesting if it changes from day to day. However, if the protagonist, were not like white rice, but like fried rice or chicken and rice, wouldn't you grow tired of it? That is why the uniqueness of the protagonists pictured at the bottom of p. 111 were minimized somewhat.

Chapter 4

○○○○○○

Super-deformed Character Odds and Ends

Let's Compare!

○ ○ ○ ─────────────────────────────────────

Here's a little bonus. I wondered what it might be like to redo using stylized characters a collection of *manga* shorts that were published some time ago, so I played around a little, and the results are what you see on the next few pages.

Ironically, I do draw considerable amounts of regular *manga* (chuckle), but for some reason I just can't shake my reputation as a gag *manga* artist. So, I figured since that is what people think of me anyway, I might as well parody my own *manga*. The published collection consisted of 4 regular shorts. At the volume's end I added a brief, collective parody of the preceding shorts (grin). I hope you enjoy comparing the originals with their parodies.

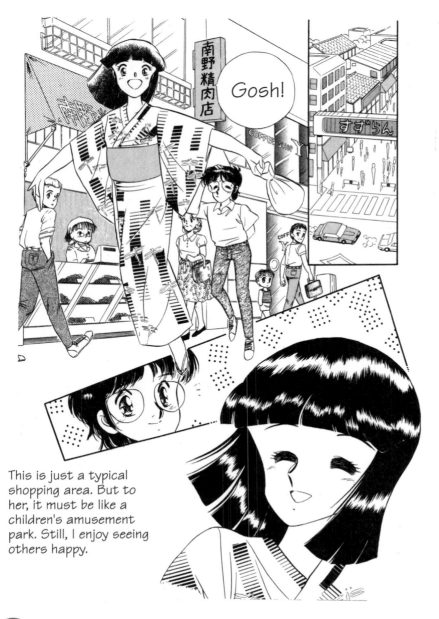

This is just a typical shopping area. But to her, it must be like a children's amusement park. Still, I enjoy seeing others happy.

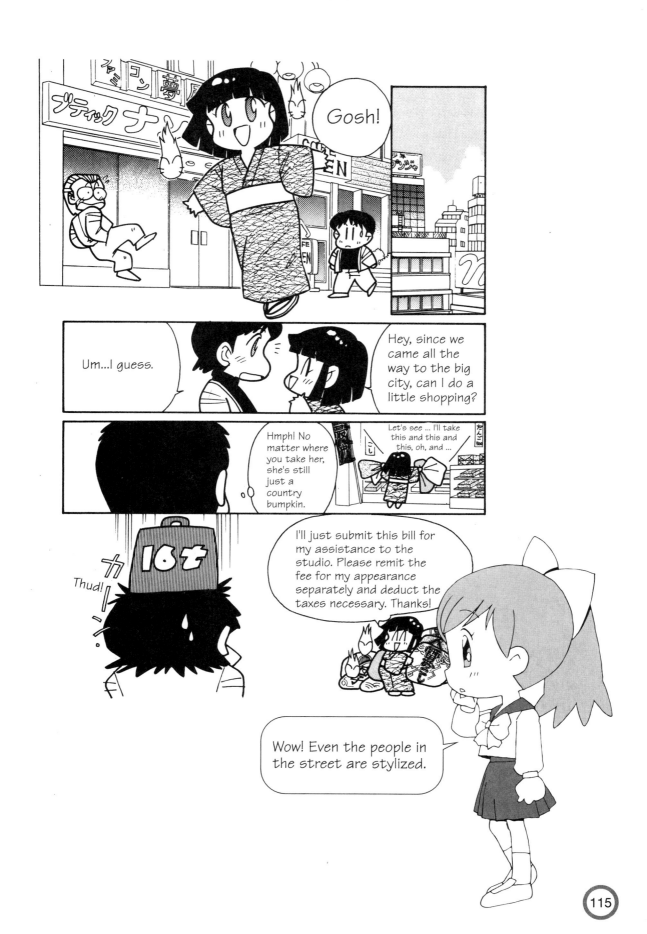

Note that the backgrounds are also stylized.

Realistic *manga* is an experimental work, where the artist can play with expressions in lines and planes. Thus, parody *manga* may have more of a sense of volume (wry laugh).

A parody of a sentimental ending can look like...

Sorry folks. This collection of shorts is out of print and can only be found now at used bookstores, online auction sites, or reissued publication sites.

Special Bonus
Mix and Match to Improve Facial Layout Skills

You have probably gained an understanding of how important the facial layout is to a super-deformed character. So now, let's work on your layout skills using this special bonus supplement mix-and-match.

You'll have even more fun using eyes, mouths, and other features that you draw yourself. Play around with different features and try designing your own facial layout.

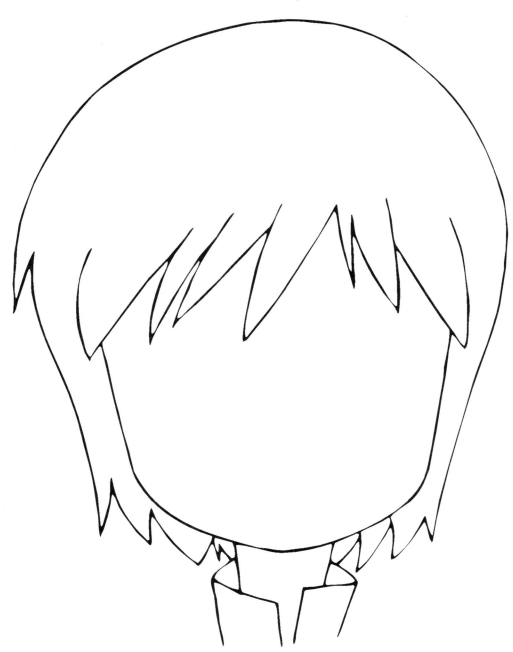

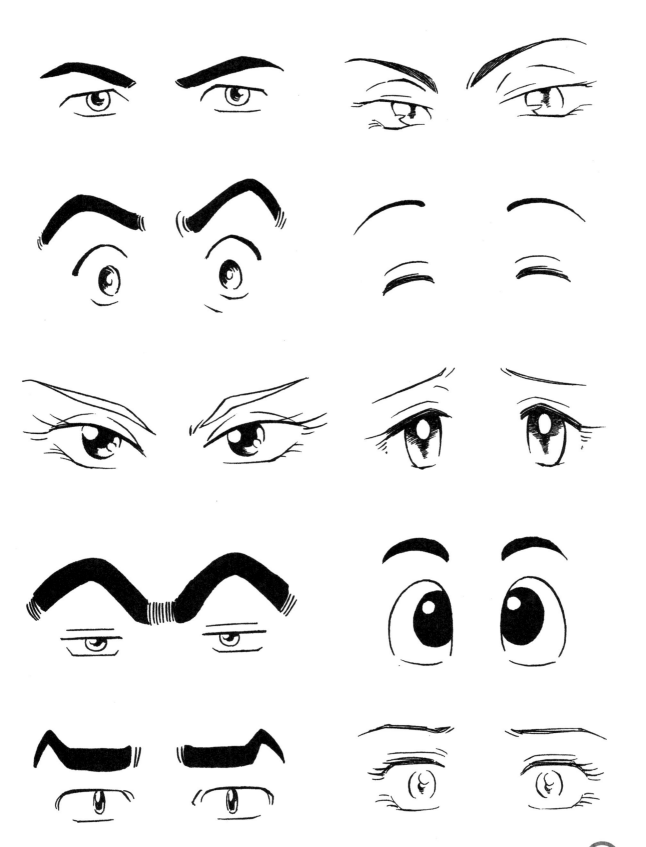

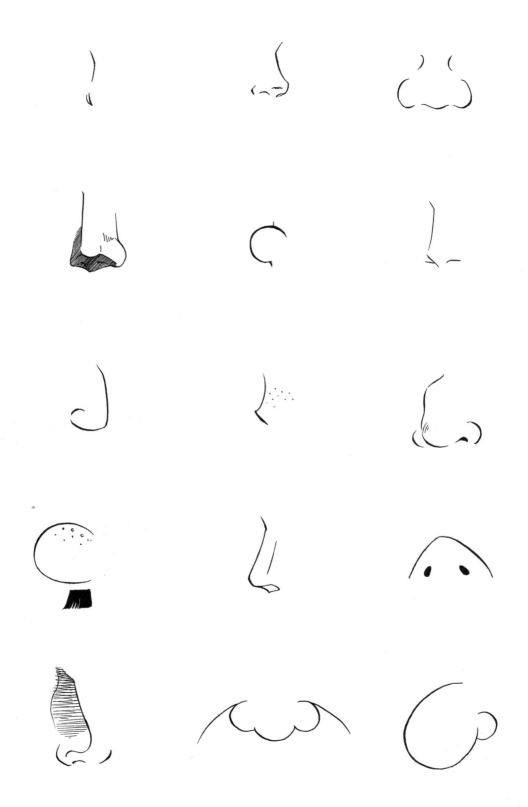

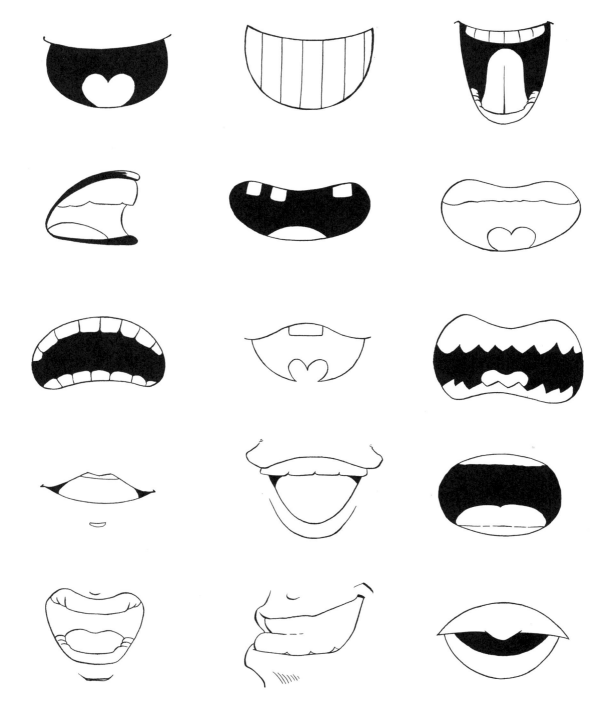

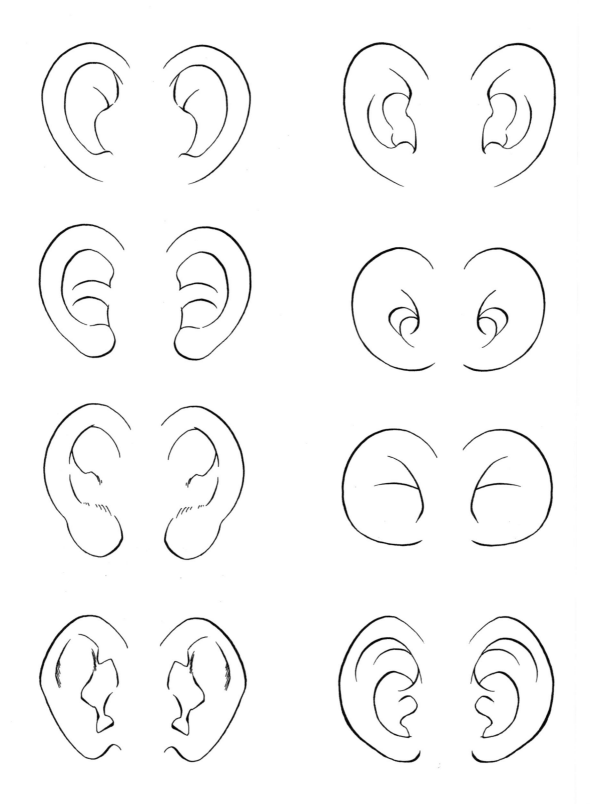

Afterword

As the book's author, I sincerely hope you have acquired some appreciation of super-deformed characters. Still, I realize that you have been introduced to only a portion of stylistic techniques given the limitations of that presented in this volume. To understand super-deformed characters, an artist must start by gaining thorough familiarity with the actual human form and realistic drawings. Realistic drawings involve little transformation of the original picture or photograph and, consequently, are rather easy to draw. However, drawing super-deformed characters requires that the artist overcome various constraints, so they do take exponentially more time to draw than realistic drawings. Simply drawing and abbreviating is not how to create a super-deformed character. I personally believe that a character will respond and last for years to come if it is executed in a manner that allows it to live within the world you created. I encourage the reader to create super-deformed characters with even more interest and appeal.

Artist Profile: Gen Sato

Sato debuted as a *manga* artist with his "*Gundam*" parody work, "*Bakusho Senshi SD Gundam*" (Riotously Funny Warrior SD Gundam), published by Kodansha. Sato is currently active as an anime and *manga* creator as well as an instructor of new generations of artists at various trade schools.

• **Anime Projects Participated**
"*Ojamajo Doremi Dokkaan!*" ("Pestering Witch, Kaboom!"), "*Ashita no Naaja*" (Tomorrow's Nadja), "*Ippatsu Kanta-kun*" (One-hit Kanta), "*Shin Lupin-sansei*" (New Lupin III), "*Sutajingaa*" (Spaceketeers"), "*Gatchaman II*," "*Pinkuredy Monogatari*" (Pink Ladies' Story), "*Ashita no Joe II* (Tomorrow's Joe II), "*Uchu Senkan Yamato II*" (Space Battleship Yamato II), "*Zendaman*," "*Ginga Tetsudo 999*" (Galaxy Express 999), "*Uchu Senshi Baldios*" (Space Warrior Baldios), "*Sengoku Majin Goshogun*" (Goshogun, Demon of the Warring States), "*Daioja*," "*Gundam II*," "*Gundam III*," "*Votoms*," "*Crusher Joe*," "*Kyojin Gogu*" (Giant Gogu), "*Dirty Pair*," "*Futari Taka*" (Two Hawks), "*SD Gundam I*" through "*SD Gundam VI*," "*Maitchingu Machiko-sensei*" (Miss Machiko), "*Manga Hajimete Monogatari* (First-Time-in-*Manga* Stories), and many more.

• **Comics**
"*Oyasumi! Watashi no Saiboi*" (Goodnight, My Cyborg Boy; Tokuma Shoten Publishing Co.), "*Aidoru Tantei Hiroshi ni Omakase*" (Leave it to Hiroshi, The Dashing Detective; Tokuma Shoten Publishing Co.), "*Famikon Hissho Dojo*" (Family Computer, Go Ahead and Laugh; a three-volume series published by Kodansha Ltd. Publishers), "*Bakusho Senshi SD Gundam*" (Riotously Funny Warrior SD Gundam; an eight-volume series published by Kodansha Ltd. Publishers), "*Mina-san! Banbaman desu yo!!*" (Everyone! It's Bomberman!!; a four-volume series published by Kodansha Ltd. Publishers), "*Binpatsu Ichiban*" (Best in Hair; a two-volume series published by Kadokawa Shoten Publishing Co., Ltd.), "*Famikon Tanteidan*" (Family Computer Detective Squad; a two-volume series published by Akita Publishing Co., Ltd.), and many more.

• **Others**
"*Nippen no Miko-chan*" (third generation of the commercial *manga* character),
Movie: "*Tokiwa-so no Seishun* (Tokiwa: The *Manga* Apartment; served as *manga* production supervisor),
Nippon Television FAN (as program illustrator, etc.)

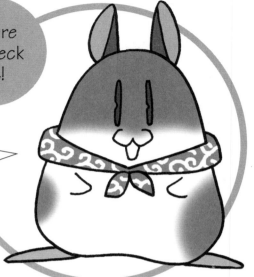

Be sure
to check
it out!

We're covering animals in
How to DrawManga:
Super-Deformed
Characters **Vol. 2**!!